For Oli and Josh.

To John For an should future with respect! Hope you enjoy it!

The Magic in the Space Beyond

MS 2023

TRANSFORMATIONAL
CASE STUDIES FROM
THE FRONTIERS OF
WOMEN'S LEADERSHIP

EDITED BY IAN WIGSTON

First published 2022

by John Catt Educational Ltd,
15 Riduna Park, Station Road,
Melton, Woodbridge IP12 1QT

Tel: +44 (0) 1394 389850
Email: enquiries@johncatt.com
Website: www.johncatt.com

ISBN: 978 1 915261 72 4

Set and designed by John Catt Educational Limited

Contents

Prelude

Getting off the shuttle bus in Boston on 25 June 2022, the first building I encounter is a white mausoleum-like structure with the aura of a temple. It is a sharp, clear, sunny afternoon and the Edward M Kennedy Institute for the United States Senate has an unvisited, almost pristine quality. There is no litter, no people are in sight and the building appears almost ghostly. I take a photo, for the record, and walk along the path to the next building.

My reason for being here today is to visit the neighbouring John F Kennedy Presidential Library and Museum. It is one of 15 libraries across the US dedicated to the life and work of previous presidents. I was eight years old when JFK was assassinated – the first time I had heard the word used. It was a Friday evening in November 1963 and I remember vividly that I was with my father having my hair cut at our barber's in St Anne's, a small town in Lancashire, England, when news of the assassination broke.

But JFK is not the main reason I am here. His brother, Robert F Kennedy, was assassinated in June 1968, shortly after he had won the California presidential primary election. "So it's on to Chicago and let's win there" were his last words to his fans in the early hours of 5 June – pointing the way to the Democratic Convention in Chicago some 11 weeks hence. A few minutes later he was shot and he died the following day.

My family had moved to Seattle in 1966, my father a part of the so-called brain drain that took British aircraft engineers to the Pacific Northwest. My school, Bellevue Junior High, was a yellow school bus ride away from

our new home. My interest in Bobby Kennedy had been sparked by my social studies teacher, Mr Stuart, who was a Kennedy campaigner and had inspired many of us in the class to follow his speeches and campaign closely. I had a badge that proclaimed "RFK for President '68". Bobby had a similar heroic quality to his brother. Seeing him nightly on the news made a welcome change from the haunting images of the Vietnam War that often preceded him.

At the JFK Library, I start chatting to a friendly, engaging man named Michael who sits behind the reception desk. He gives me a sticker to show I have paid the admission fee and points out the main features of the building. We quickly discover a shared interest in Bobby. Michael was born in the year the construction of the library was completed, 1979, so is much younger than me and never saw JFK or Bobby alive. He points me to the room in the building dedicated to Bobby – a recreation of his office when he was Attorney General in his brother's cabinet.

My visit completed, I return to reception and explain to Michael that I am waiting for a colleague to arrive so will probably hang around for a while. He gives me somewhat conspiratorial look and hands me a yellow envelope. "I think you might be interested in this," he says. From the envelope I remove what I can see is an RFK campaign poster from 1968, picturing a youthful and energetic Bobby greeting supporters on the campaign trail. Keen not to damage this gift that has made my day, I don't inspect it closely but instead offer my thanks to Michael and return it to the safety of the envelope.

It's only later, back in my hotel room, that I take another look at the poster and realise its significance. It features Bobby's campaign slogan, and these words have a clarity and brilliance that stuns me: "The youth of our nation are the clearest mirror of our performance."

Ian Wigston, October 2022

Introduction

'In the final analysis, our most basic common link is that we all inhabit this small planet. We all breathe the same air. We all cherish our children's future. And we are all mortal'

President John F Kennedy, Commencement Address at American University, Washington DC, 10 June 1963

'The monolingualism of a large section of the American population is inextricable from our political peril and an inability to imagine otherness without fear and terror'

Ben Lerner, discussing his novel Leaving the Atocha Station on BBC World Book Club, 3 September 2022

Setting the scene

Our first book, *The Magic in the Space Between* (2021), described the genesis and outcomes of a pro bono mentoring programme to support the goal of the Girls' Schools Association (GSA) and the Association of State Girls' Schools to improve the pipeline of women's leadership in girls' schools in the UK. Three cohorts of aspiring women leaders worked successfully with mentors from commerce, the public sector and the military to develop their leadership confidence and competence. Between 2017 and 2020, in tandem with learning partners across different settings, these participants also produced a range of community projects exploring topics including pedagogy, perfectionism in girls' schools and STEM.

More than 50% of the first cohort of 60 won promotion, to headship or other roles. In some cases, they moved away from education to work in industry, consulting or to establish their own businesses.

When planning the next cohort in early 2021, the Covid-19 pandemic was taking its toll in terms of illness, lockdowns and loss. Students and teachers were adapting to new technologies and altered pedagogy. Political, medical and educational leadership was being challenged uniquely and on a global scale. Scenarios previously regarded as unthinkable were playing out in an unrelenting environment. School leaders were having to respond to changing diktats from education ministries, sometimes repeatedly over the course of a day, with a consequent impact on their mental health and that of their colleagues and students.

It was against this background that Megan Murphy, then executive director of the National Coalition of Girls' Schools (NCGS) in the US, approached Bright Field, the consultancy founded by Hilary Wigston and me, with a request to involve North American colleagues in the next cohort. I had spoken at the 2019 NCGS conference in Pasadena, California, and had regularly met Megan during her visits to Europe. Bright Field already had clients in the US and we had been using Zoom and other technologies over the previous year to conduct one-to-one and group workshops.

I got in contact with members of our US associate base, who were keen to become mentors. Following a similar pattern to the UK, these were colleagues and friends who had experience of organisations as diverse as Microsoft, Recreational Equipment, Inc. and HomeGrocer.com, and who had also worked extensively outside the US.

At the time, the NCGS was in discussions with Loren Bridge, the executive officer of the Alliance of Girls' Schools Australasia (AGSA) about a potential merger. The AGSA was also keen to take part in the programme. Within a few weeks, participants in Australia and New Zealand had been invited to join what was now the Global Mentoring Network for Aspiring Leaders.

We had accumulated experience of pairing mentors with mentees during the earlier cohorts based in the UK. Now, with a global network, there was an opportunity for mentees to work with an overseas mentor. The

community project aspect of the programme had often been cited as the jewel in its crown. As mentees stretching from Perth to Johannesburg were paired up to work together on a project of their choosing, those projects took on a significantly broader scope, provided that colleagues could add differing time zones, school and national cultures, and partner predispositions to their daily routine.

Gillian Tett had been the first journalist to anticipate the 2008 financial crash in her book *Fool's Gold*. In the introduction to her latest book, *Anthro Vision: how anthropology can explain business and life*, she succinctly describes three core principles of anthropology that helpfully underpin the project component:

> *The first idea is that in an era of global contagion, we urgently need to cultivate a mindset of empathy for strangers and value diversity ... The second key principle of anthropology is that listening to someone else's view, however "strange", does not just teach empathy for others, which is badly needed today; **it also makes it easier to see yourself** [Tett's emphasis] ... Third, embracing this strange-familiar concept enables us to see blind spots in others and ourselves.*

As with the earlier cohorts, all participants took the Insights Discovery Evaluator, a Jungian psychometric questionnaire, at the outset. Included in the results is a summary of their conscious and less conscious predispositions – this shows the extent to which conscious energy is applied by an individual in order to meet the perceived demands of their job. Their blind spots are also revealed, enabling a greater self-awareness and, more importantly, a heightened understanding of team dynamics.

For many of our mentees, the chance to have an independent, objective mentor proved a godsend at a time of such turbulence. Many of them spoke about the sense of renewal and re-engagement that their conversations had brought about. Unsurprisingly, a number used the programme to seek new opportunities and more than 10% of the cohort gained promotion during the year.

For others, the culmination of the programme came at the International Coalition of Girls' Schools Global Forum on Girls' Education in Boston in June 2022, presenting a paper live with a colleague met face to face for the first time a matter of a few hours earlier. Others responded with

virtual presentations. No matter the mode of delivery, the participants were unanimous in acknowledging the power of their mentoring and the projects in developing their skill base and building their confidence on a world stage. Their presentations can be watched on Bright Field's YouTube channel: bit.ly/BrightFieldYouTube

The papers presented in this book fall into four groupings:

Student wellbeing

Punam Bent, from Pymble Ladies' College in Sydney, Australia, and Kate Hawtin, from St Catherine's School in Surrey, UK, had both expressed an interest in exploring social media in their joint project. They had contrasting but complementary predispositions and helpfully different perspectives: Punam is her school's chaplain; Kate is head of sixth form. They were also more than 10,500 miles and nine time zones apart.

Punam and Kate were keen to challenge what were in danger of becoming accepted views on the power and influence of social media. As well as introducing their audience to the concept of influencer deification, their study of students in Sydney, Surrey and India brings a truly global perspective to bear on one of our age's most intractable problems: balancing the benefits of social media against the addictive and potentially harmful qualities of the medium.

One of Punam's colleagues, Kate Brown, worked with a younger cohort of students in the junior school at Pymble and hosted a conference for other schools in Sydney in her thoughtful and wide-ranging study of kindness. Her paper highlights the power of student voice among younger pupils, as well as the impact of bringing neighbouring schools into the conversation.

The pandemic has provided a backdrop for a number of papers and Kathryn Anderson's study of student wellness draws inspiration from the circumstances created by Covid-19.

Meanwhile, Cathryn Furey's paper, building on the work of the researchers Andrew Martin and Rebecca Collie, provides helpful and powerful evidence from her Year 6 students to reinforce the theory underpinning academic buoyancy.

Pedagogy and curriculum

Clare Duncan's study of neurodiversity gives voice to an often misunderstood group of students and does so powerfully, using their words and imagery. Here, the pandemic plays little or no part in the story, which showcases the leading-edge work being done by Clare and her colleague Isabelle Alexander.

Kate Banks and Ellie Peaks both had changes they were keen to introduce to their respective curricula. In Kate's case, her first challenge was how to balance the fast pace at which her school liked to work with the premise of not progressing to the next stage of learning until the current stage has been mastered. For Ellie, there was a parallel insight in recognising that change itself is complex and personal: one of a leader's most important roles is to serve as a guide to colleagues and students. For Kate and Ellie, as for others in the cohort, much of the benefit in being paired came from the dialogue they were able to enjoy with one another, which complemented their separate mentoring conversations.

When I paired Tara Quenault and Susanna Linsley for their project, an outsider might have perceived their shared interest in experiential learning as a risk, given their contrasting subject expertise in science and the humanities respectively. However, in their interviews prior to joining the network, both had impressed me with the breadth of their interpretation of their subjects and their high level of pedagogical skill. As a direct result of their collaboration, new courses have been introduced at their schools.

Our next Anglo-Australian collaboration is a paper that explores the impact on student perceptions when increasing the immersion of community values and diversity. Michelle Fitzpatrick and Joanne Wallace's schools both introduced changes to curricula during their mentoring year. Their detailed exploration of the impact on students throughout a year punctuated by lockdown is a helpful reminder of the power of student voice in challenging assumptions that, if ignored or suppressed, can increase the risk of projects being derailed.

There are a number of mathematicians in the group of mentees, some of whose papers will see the light of day in due course. TC Nkosi-Mnanzana's study is remarkable for its energy and message. Given the twin contexts

of the pandemic and students' often negative attitude towards maths, TC shows how improving relatability and student interaction, despite the legacy of the pandemic, can overcome initial perceptions.

When Erin Skelton's learning partner was unable to devote sufficient time to their project, Erin decided to take the opportunity to review her own journey as a leader since coming to the UK from Canada. The perspective she shares from a range of state and independent institutions is a powerful reminder of the different challenges faced by leaders in those settings. As she states, "Working within a trust of girls' schools gives a unique insight into the impact of single-sex versus co-educational learning environments and, when intersectioned with racial and socioeconomic inequalities, this again changes."

Professional development

Having conceived an early coaching project in a commercial setting some years ago, I empathised with the frustrations voiced in Stephanie Walton's paper on getting started with coaching. In the 1990s, coaching was in its infancy and the pressures then were of budgetary constraints and relevance. One of the barriers often put in the way of coaching in schools is the lack of time available for such conversations: coaching is perceived to be time-consuming. However, as Stephanie's paper attests, with the proper context and appropriate trust between the respective parties, it is possible for coaching to occupy comparatively little time, certainly for the gains in performance that it can bring about.

The partnership between Alexandra Greenfield and Karen Whelan is a thoughtful Anglo-Australian collaboration that focuses on middle leaders' professional development. As well as helping to clarify the often vague boundaries of middle leadership, the authors are careful not to overlook the skills and talents that frequently sit within a school's own corridors. Their research highlights the danger of assuming the perceived needs of middle leaders and the power of carefully structured enquiry.

Rachel Hart was a member of an earlier cohort whose mentoring took place during the early stages of the pandemic. As she suggests in her paper, there was an integrative element to her mentoring that empowered

her to realise that the various roles she had held inside and outside the classroom could co-exist in relative harmony.

Life after school

In the early cohorts of the programme, we paired state and independent school colleagues where possible, so that as well as considering their project subject matter, they also had to take account of different demographics. Jericah Jackson and Juliet FitzGerald work in schools in Texas, US, and London, UK, that have respectively a one-year and a 312-year history. Although their contexts could not be more different, the similarities they discovered and the parallels between their institutions are testimony to the power of girls' schools.

In a similar vein, the dialogue between Margaret Powers in Virginia, US, and Diana Kelly in Melbourne, Australia, benefited from what Diana subsequently described as "the journey of what two people on opposite sides of the planet have in common". Paradoxically, their "playbook for teaching the skills and mindsets needed in a diverse and changing workplace" emerged when other project avenues were frustrated.

Bibliography

Tett, G. (2009) *Fool's Gold: how unrestrained greed corrupted a dream, shattered global markets and unleashed a catastrophe*, Abacus

Tett, G. (2021) *Anthro-Vision: how anthropology can explain business and life*, Random House Business

Student
wellbeing

Deities of our time: social media influencing and impact on senior high school girls

PUNAM BENT AND KATE HAWTIN

Introduction – Kate Hawtin

My idea was very broad: research into social media use and influence leading to the introduction of new initiative/s to harness the positive side of social media and combat the negative.

Punam was more focused in her suggestion, which was the idea of the deification of social media influencers. Why did we choose this topic? Because we are interested in its effects: we can't fight it, so perhaps we need to embrace it.

As educators, we are quick to blame social media for putting girls under pressure to look a certain way. I hate the way that perfect snapshots of lives are portrayed on social media, giving the girls unrealistic expectations and just setting them up for disappointment. Lots of them spend too much time scrolling. But, equally, it's here to stay, the girls love it, so we need to learn to work with it and find some positives from it.

When we speak about cyber-safety and the essential nature of keeping up to date with making the internet a safe space for our children, we can apply the same kind of intention/vigilance to being aware of the content influencing our students, and our project focuses on senior high school girls. We were able to work within three contexts: St Catherine's School

in the UK, Joy Secondary School in India, and Pymble Ladies' College in Australia.

Girls as happy, healthy individuals are the ones who can influence others in the community through their voice.

Background research and reading – Punam Bent

Social media is here to stay. This is the mode or way in which our young people, boys, girls and all genders relate to one another.

Given that our high school girls are graduating in a pandemic time, this has had a growing impact on how they perceive life and respond both locally and globally.

Through our project, we were mindful of the positive leaders in social media who are making more than a shift in the minds of young people, so this is not intended as a critique of all influencers.

If we look up the word "influencer" on UrbanDictionary.com, this is what it comes up with:

> *A word Instagram users use to describe themselves to make them feel famous and more important when no one really know who they are or care, usually the type of people that call themselves foodies and post pictures of their avocado and toast cause they can't really do anything else interesting, usually also post their last holiday asking someone to #takemeback*

Clearly, the word "influencer" has been absorbed into the Instagram, TikTok and social media culture. The "flavour" of influence could range from fashion to cultural and lifestyle preferences, religious, philosophical and political thought – the list goes on. It is in these spheres of influence that we find our students seeking, grasping, needing and sometimes unfortunately hiding behind the "influence" of their favourite influencer.

We do not use the word "influencer" as we would have done 12 years ago. When I arrived in the US last week [June 2022], an influencer called Niece Waidhofer, who was 31, had sadly just taken her own life. She had more than four million followers on Instagram.

A lot of the discussion between Kate and me over the past year has been around wellness and the wellness of our girls. You wonder about the girls who are following this person who gave up on life; her area of influence was mental health. This is the kind of quandary we find ourselves in: we don't want to demonise all influencers.

On 9 May 2022, the professor and author Brené Brown posted on Twitter: "An awkward, brave, and kind plan to rest and create some silence in the noise." She spoke about reinvesting in this space and taking a sabbatical by going "dark" on social media. As a positive influence, she prompts her followers hopefully to emulate this pause.

We then face the deities of our time, many of whom are unreachable in their expectations of a way of life, invoking a following of thousands. So, who are these deities? What is it about them that draws our young people? Click-of-the-button research will be enough to tell us that this influence is impacting younger minds and begins with the YouTube following of a favourite artist or celebrity.

Ramani Durvasula is a US clinical psychologist, psychology professor and media expert. As she writes, "We are living in a time of trickle-down narcissism, incivility and toxicity" (Durvasula, 2021). According to Durvasula, "'Don't you know who I am?' is the buzz phrase of our time – and, clearly, the mantra of the entitled and narcissistic." In internet circles, this phrase is referred to as DYKWIA.

For high school girls in an environment where achievement, celebratory hashtags and evidence of continuous growth are key to success, this area can be most harmful, especially if they are following a narcissistic influencer. There is a cult-like resonance in a youth culture that follows an influencer to the point of absorbing the identity of the person they are following. Their life practice and social behaviours are all that they are seeking to emulate.

The impact of such influence is determined by the superficial nature of engagement with the promise of a relaxed lifestyle, exotic holidays and unreal body images, all captured digitally, filtered through and magnified with hashtags. The FOMO (fear of missing out) factor gives rise to ongoing anxiety and a fear that if one does not have or own a certain lifestyle, one won't be successful.

Our focus is on mental health. It's been proven through social research – for example, by Jonathan Haidt – that since 2010 there has been a rise in anxiety, depression and self-harm among American teens and those around the world. The cause isn't known but can be directed to social media as a chief contributor.

Steps in research and survey results – Kate

We began our research with a small group of senior girls. We sought their initial views and asked their advice as to how to form the questions for our survey, which would be used in all three schools. We wanted to hear what the girls thought and we wanted them to educate us on the topic.

In the event, we got a good number of survey responses from each country:

- UK: 73.
- Australia: 64.
- India: 46.

We then asked the girls how much time they spent on social media, and which platforms they preferred to use.

Roughly how much time per day do you spend on social media?

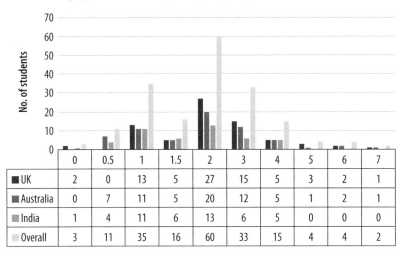

No. of hours	0	0.5	1	1.5	2	3	4	5	6	7
■ UK	2	0	13	5	27	15	5	3	2	1
■ Australia	0	7	11	5	20	12	5	1	2	1
▒ India	1	4	11	6	13	6	5	0	0	0
░ Overall	3	11	35	16	60	33	15	4	4	2

No. of hours

Which social media platform do you use the most?
Please note that many students use multiple platforms.

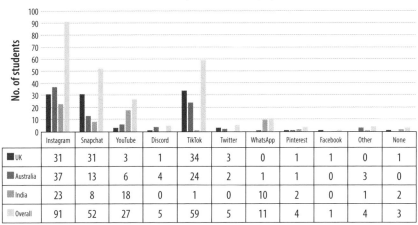

	Instagram	Snapchat	YouTube	Discord	TikTok	Twitter	WhatsApp	Pinterest	Facebook	Other	None
■ UK	31	31	3	1	34	3	0	1	1	0	1
■ Australia	37	13	6	4	24	2	1	1	0	3	0
▒ India	23	8	18	0	1	0	10	2	0	1	2
░ Overall	91	52	27	5	59	5	11	4	1	4	3

Social media platform

Then we asked which influencers they followed. The names and categories are as you would expect, but it was interesting and encouraging to see the range, especially the influencers focusing on mental health, racial equality and disability rights.

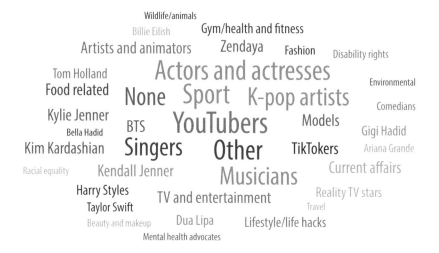

We asked how much influence these people actually had on the girls and on the decisions they make in their own lives. Here, just under 50% acknowledged that the influence ranged from "some influence" to "a significant amount".

Finally, and most importantly, we asked if they had any ideas about how we could champion positive influencers in school, to harness the positive side of social media.

"A good example of a positive social media influencer is @Iweigh. Founded by Jameela Jamil, feminist and activist, it is a great platform for young people and perpetuates healthy and accepting views surrounding self-love. Combating the harmful, unrealistic ideals of women and oppression faced in an intersectional manner, iweigh takes how society and consequently women value themselves away from weight, appearances and other superficial measurements. Rather, encouraging young women to value themselves on their personality, their achievements, their roles and many other aspects. It is truly empowering and special to see someone use their platform for such a good cause. Jameela, as a queer woman of colour, is a great influencer for young people, in my opinion. Her activism and portrayal of self on social media is honest. In addition, her personal Instagram account is a great platform for her to educate and evaluate those biases that are apparent in social media."

"By suggesting influencers who stand for what the college stands for – i.e. feminism, activism, etc. (and not just tokenism) – then we can see a shift in attitude towards social media. I think a lot of the resentment that comes out of social media (from both younger people and older people) is because of what we as a society choose to follow and admire (i.e. people who represent the archetypal beauty standards and go to the gym 14 times a week). But if we choose to channel the powers of social media to influence young minds for better things – i.e. following people who care about the world and are active in their compassion for other people – then social media can reach its full potential as being a way to connect our world."

"Complete criticism of social media by parents, teachers or anyone older should be stopped. As a result of this criticism, the thought that social media is just for fun gets etched in students' mind. Therefore they are unable to explore the positive side of social media."

Many responses tied in with what we said earlier about embracing social media. Many girls gave accounts of names they followed that are positive influences, as well as giving great suggestions about educating younger girls about algorithms on social media platforms. If they make good choices and follow meaningful influencers, more of those types of influencers will be suggested to them.

They also mentioned the need to educate teachers and parents about the changing face of social media and that it can be a positive thing, effectively acknowledging the point about recommending accounts that are allied with the school's aims and ethos.

We collated the responses and arranged a time to meet with a few girls from each school, to check their reactions to the results…

How much time per day do you spend on social media?

"Subconsciously they may not know, because sometimes you can be scrolling for hours and not realise it! Also, some people don't realise that they spend as much time as they do."

Which accounts have a good influence on young people?

"I've started following a few spoken-word poetry accounts, and it's often related with mental health issues, equality or any issues around the world. Their poems help bring awareness to these issues. The people who speak them are very calming, almost with a meditation. A lot of them help us get informed about things and a lot of them are positive affirmation, so it's good to do when you are stressed. That's had a very positive impact on my life."

"The idea of promoting positive influencers is a good idea: there are some influencers that are really amazing – they may just not be all that well known. They may not fall into these girls' 'recommended' lists. Having the opportunity to show it to them and introduce it to them and give it a chance to take prevalence, and then in doing that and getting those positive accounts, even more of that could be recommended to them via the algorithm and things like that."

"In our school [Pymble] we have our student-run Instagram account. The [Year 12] prefects run it and if we facilitate it through Instagram using Instagram influencers, it's a pretty easy way for students to check the tag, then go to the account. A lot of our students follow that account and younger students look up to our Year 12s especially. Them being able to see us and know that we support these things and like looking at these things [are all positive trends]. The Year 12 account has the capability to be even better: looking at the survey results, I think we can do so much more with it now and do so much better."

How much influence does social media have?

"I think we should have a strong self-concept to protect us from the bad influencers. Once you understand that what's false isn't real and

what's real isn't false, it would be easier to protect ourselves from the bad influencers…the pictures are so perfect that we want to be like them. We should know what is good and what is bad: we should be strong enough and we should be sure enough that we know what is correct. These are tomorrow's citizens: youth has a responsibility for the future. The centre ground should be promoted by us so that youth has a good choice."

What next? Possible initiatives to be used in school – Punam

Generational space has to be given to young girls to come to their own and find their path through choices they make for their present and future. As Jonathan Haidt (2022) suggests, thought should be given to greater monitoring and access by parents so that children are delayed in the process of attaching themselves to social media.

According to Durvasula:

> *Parents, educators, and academic and occupational curriculum all need to focus on building digital literacy and social skills. Critical thinking about all things media is absolutely essential, must start at a young age through the schools, and should be a central pillar of all K-12 and post-high school curriculum.*

When we speak of generational space, it also means that as educational leaders we need to review, reassess and make possible a platform for young women that won't pressure them to perform to unrealistic levels. Girls who dig deeper into the axis of things and delve into social justice advocacy and change are the ones who are already moving beyond hashtags. They are shaking the superficiality of a system dependent on likes, dislikes and heart emojis. These are our students. Our students know that sharing a post to take a stand urges them to move to action in order to make it happen.

Many of our schools have assigned wellbeing weeks through the year, which could be set for every term. This could be a weekly space to encourage mental health conversations, slowing the pace of the day or involving the students in outdoor activities like gardening, clearing up rubbish to help the environment or going for a bush walk. Lower-intensity, as opposed to the more hardcore Duke of Edinburgh scheme challenges, is key to slowing the pace for young girls and women.

The positive use of Instagram and other platforms like TikTok could be for social justice issues. School leaders at Pymble spoke at a Zoom meeting of how the prefect leadership Instagram page, which is followed by many students, could showcase a fortnightly post of motivating influencers.

At Queenwood School in Sydney, they restructured the timetable to designate a time in the day for all students from kindergarten to Year 12 to "Just Read!" for 20 minutes. The research behind it said that 15 minutes was too short and 20 could just work. "Just Read!" time is not catching up on school texts, even if the students are reading novels.

Within six weeks of this initiative, parents noticed a significant difference in the way their daughters thought of reading and giving them an alternative to a device in hand.

Ultimately, the challenge lies with the educators and leaders, especially women who pave the way for the younger generations. Through our survey responses, we discovered that students don't necessarily feel their voices are heard by the older generation. Gen X and millennials did not and will not face the challenges that Gen Z face. "Stuff" is not making this generation happy and a pair of sneakers or a Gucci handbag will not get them nirvana.

According to the journalist and author Madonna King, schools are discussing mental health but the support to girls in high school years is unrealistic. The wait list to see a counsellor is very long and there are often not enough psychologists at school to provide the mental health support needed. Parents in turn need to be informed, educated and equipped as co-partners in caring for and equipping our girls with resilience and life skills.

My thoughts on the subject gravitate towards an extra responsibility towards girls from cross-cultural backgrounds, for whom a dual existence and the tension they experience is causing further mental ill-health. A healthy response for girls from minority ethnic backgrounds within Western communities is lacking. This is another project for another day. We have to understand the need for young women to see diversity in key influencers, so that the themes of racism and intersectionality may not just be articles or speeches that sound great. These have to be lived experiences. Gen Z will have it no other way.

Spirituality, global perspective and social justice activism, whether for the environment or the local aged-care centre, will bring life to the present and promote inner growth, self-actualisation and self-esteem, which are key to fostering healthy and happy girls.

However, a note of caution. We do need to unpack what it means when we say "happy and healthy girls": happiness isn't a default setting that qualifies a necessary action that will bring about personal or outward change. A holistic and real-life approach to mental health will empower our young women to be in touch with even their sadness, and to respond with compassion and humanity to their own selves and those around them.

The day needs to come when wellbeing is not just a curriculum but a way of life stemming from our staff community to our students. Let us attend and listen to the voices of our girls. They are speaking, they have their ear to the ground, and they should and will be heard. If we can put our devices to the side.

Bibliography

Baird, J. (2021) *Phosphorescence*, HarperCollins

Durlofsky, P. (2020) *Logged In and Stressed Out*, Rowman & Littlefield

Durvasula, RS. (2021) *Don't You Know Who I Am?*, Post Hill Press

Edmonds, R. (n.d.) "Anxiety, loneliness and Fear of Missing Out: the impact of social media on young people's mental health", Centre for Mental Health. Retrieved 16 June 2022 from: www.centreformentalhealth.org.uk/blogs/anxiety-loneliness-and-fear-missing-out-impact-social-media-young-peoples-mental-health

Fleps, B. (2021) "Social media effects on body image and eating disorders", Illinois State University, https://news.illinoisstate.edu/2021/04/social-media-effects-on-body-image-and-eating-disorders

Haidt, J. (2022) "Why the past 10 years of American life have been uniquely stupid", *The Atlantic*, www.theatlantic.com/magazine/archive/2022/05/social-media-democracy-trust-babel/629369

Kids Helpline. (n.d.) "Social media and mental health". Retrieved 16 June 2022 from https://kidshelpline.com.au/teens/issues/social-media-and-mental-health

King, M. (2022) *L Platers*, Little, Brown

McCluskey, M. (2021) "From Instagram's toll on teens to unmoderated 'elite' users, here's a break down of the *Wall Street Journal's* Facebook revelations", Time, https://time.com/6097704/facebook-instagram-wall-street-journal

McDonald, L. (2022) "Seven things our high-school daughters want us to know, and what you can do to help", ABC News, www.abc.net.au/news/2022-06-01/seven-things-your-high-school-daughters-want-you-to-know/101109988

Neal, K. (2021) "10 books about the effects of social media", She Reads, https://shereads.com/books-effects-social-media

Oakes, K. (2019) "The complicated truth about social media and body image", BBC Future, www.bbc.com/future/article/20190311-how-social-media-affects-body-image

Oshry, C. (2021) *Girl With No Job*, Gallery Books

Queenwood. (2020) "It's not rocket science – Just Read!", www.queenwood.nsw.edu.au/Queenwood-News/Junior-School/It-s-not-rocket-science-Just-Read!

The kindness revolution: how a focus on kindness can help our girls flourish as learners and leaders

KATE BROWN

I arrived at Pymble Ladies' College at the start of the pandemic, which caused me to think about what I could do to help our students from kindergarten to Year 6 connect with each other, connect with their learning, connect with their community and, most importantly, connect with themselves and understand who they are as learners and who we are.

Context

Pymble is an independent girls' school in Sydney, Australia. We have nearly 800 girls in our junior school, from kindergarten to Year 6, and nearly 2000 girls across the whole college. It's a very traditional school, more than 100 years old. Trying to balance all those expectations and to empower young girls to believe in themselves, believe in their voice and see what impact they can have in their world and in their learning, was what drove me to focus on this.

The strategic focus for our school is "Watch us change the world".

We've had two years of Covid-19 and that has seriously impacted young girls' capacity to grow, to know themselves and to celebrate their strengths through social interaction as well as actually being at school.

We had six terms where all our girls were in lockdown and therefore in social isolation. Many of our girls have continued to learn for periods of time online – there was an absence of face-based campus learning for over 18 months. It was a very real problem for us to ensure that our girls were connecting with themselves.

And so began our focus on kindness and what difference that could make to our girls and how they could flourish as learners and also as leaders. I actually believe that kindness is a bit of a superpower that we can equip our young girls with.

We focus on kindness through three lenses: kindness to others, kindness to the environment and kindness to self. Throughout this project I have worked with Year 5 girls. These are 10-year-old girls and there are about 150 of them in that grade, so it's quite a large cohort of children that I have been able to work with. Particular credit to Dr Sarah Loch, our director of research at Pymble, who's been very much on their journey with me; she has worked with the girls and helped equip them with a sense of empowerment. The girls have been so excited every time Sarah has come down to help unpack their understanding around kindness.

How have we done this?

First, focus groups and surveys. The surveys were the starting point and then unpacking the results in focus groups that I've run over the past 12 months.

We also introduced a kindness mascot, Heidi the Hedgehog. I chose a hedgehog because I'm English and hedgehogs are very English creatures. Hedgehogs are naturally curious, so they travel a long way. They constantly question. They're quiet and often go unnoticed. I wanted the girls to be curious to be kind to themselves as learners, but also to understand that the quietest voice, the quietest child, deserves to be heard and has a powerful voice. Heidi even has a Pymble uniform.

We introduced leadership opportunities from Year 1 to Year 6, and I meet with those girls on a weekly basis and mentor them. They have ideated and considered ways in which they can bring kindness into our school and the wider community.

Kindness is now embedded into our social/emotional curriculum – our Mind Body Spirit programme, which is explicitly taught for half an hour after lunch every day.

Just last week, we ran the first Children's Kindness Convention in Sydney. We had 19 schools with over 100 children who ideated for the day around problems they themselves had identified in the world. The children tried to solve those problems or develop practical ways to advocate for change through the lens of kindness.

Questions

Here are the questions I posed to the children throughout this study.

1. How important is kindness?
2. How kind is our school?
3. How kind are we, as a school, to others within our school and to ourselves?
4. How kind are we, as a nation, to our First Nations people? How kind are we, as a nation, to people from other cultures?
5. How kind are we, as a nation, to the elderly – those over the age of 80?
6. How kind are we, as a nation, to our flora and fauna (environment)?

Answers

The children think that kindness is extremely important, as a general concept. Also, I asked them what the world would look like if everyone was kind. Their answers ranged from "People would smile more" to "There would be no war". This really empowers those children with a sense of hope, but also serves as call to action: what can you do to make a difference in your world today?

How do you feel when someone is kind to you? 93% of students feel very happy when someone is kind to them.

How do you feel when you are kind to someone else? 91% feel very happy when they are kind to someone.

Is our school a kind school? 88% believe our school is a very kind school.

Then I asked the girls to unpack that: as a junior school, how kind are we to others and how kind are we to ourselves? 96% of girls feel we are kind to others within our school. However, only 9% of those surveyed believe we are kind to ourselves. Clearly that is something we need to change for our young girls.

We then needed to unpack what "kindness to self" actually means. It's quite an abstract concept and I needed to ensure the girls understood it:

- Talk to myself with a kind voice.
- I may be nervous or unsure sometimes but that's OK.
- I will have a go!
- It's OK to make mistakes.

I then unpacked "kindness to others" into four statements:

- I can be of service.
- I can be inclusive.
- I can listen.
- I can use my voice for change.

As part of this, we introduced a Be Of Service campaign. I asked the girls to think of ways in which they could give of themselves to others, rather than just giving just gold coin donations, which is something they readily do to get a cupcake or something. But that is a contractual thing rather than actual kindness. I then gave them the challenge of getting their families on board with this: being empowered to employ acts of service around their home and in local communities. I asked whether they thought it was possible for us as a junior school to perform 1000 acts of service outside the school over this last nine-week term. They smashed it and did 1600 acts of service over the last five weeks.

Kindness is now embodied in our Mind Body Spirit programme. *Kimochi* is a Japanese word, meaning feeling, and we are really empowering our girls to know what feelings are. There are no "bad" feelings; it's about being able to articulate them and regulate them and lots of gratitude.

We have launched other initiatives within the school day. Year 4 have knitted blankets for a dog and cat rescue centre. Year 6 have worked with a Sydney charity in helping to understand and reduce food waste – they have

learned to use food scraps and cook different meals, and are developing a recipe book that they will sell to raise money for their charity.

Our children still don't feel there is the appropriate respect to First Nations people; only 56% of students feel we are kind to them. They do feel it's something their generation can change. I'm really excited about that and some of our girls will also compete in the Indigenous Games later this year. We're trying to build those connections, so the girls appreciate and understand the rich history that our nation has.

81% of students feel we are kind to people from other cultures who live in Australia; they still feel there is more that we can do. As a school, we are increasing the diversity of literature in our library. Girls now share prayer in different languages and different cultures in our chapel. We try to authentically celebrate every cultural day that is significant for all our girls and all families in our community.

88% of girls feel we are kind to our elderly; this is an area that has been really impacted by Covid-19. We are hoping to build a pen-pal programme with our elderly. Our girls are going to write to them and therefore build an understanding and a respect for the elderly within our community.

Kindness to the environment was unpacked into statements:

- I can reduce, reuse and recycle.
- I can bring "nude food" to school.
- I can pick up litter.
- I can use less water.

The children don't feel we are appropriately kind to our environment. Only 48% feel we are kind to our flora and fewer still (46%) feel we are kind to our fauna (wildlife).

During Covid-19, our Kindness Captains undertook a number of initiatives:

- Positive messages and actions during lockdown.
- Random acts of kindness within our school community.
- Writing an open letter to our families overseas.

- Launching our junior school as a Kindness Community; 1000 Be Of Service acts.
- Creating and publishing our *Kindness is a Superpower* picture book.

At last week's Children's Kindness Convention, more than 100 children – girls and boys – came together and spent the day discussing and exploring what matters to them:

- The plight of koalas.
- The amount of plastic waste in our oceans.
- The increase of household waste, particularly food waste.
- The plight of bees and other pollinators.
- Mental health concerns for young people and access to support services.
- Fast fashion and its impact on our landfill.

All the schools that took part have said they would like to return next year. We want to give the sense of the children being empowered to lead a community of kindness.

We are also building our sense of kindness across our Mind Body Spirit programme.

Mind:

- Digital citizenship program – empowering our girls to be strong online.
- Passport – introduced to build reflection on personal strengths.
- URSTRONG – our friendship programme.
- Mindfulness – painting kindness pebbles so the girls understand that every footstep we take is based in kindness. We have relaunched our junior school as a community of kindness.

Body:

- Consent education introduced across K-6.
- Unstructured play sessions.

Spirit:

- Weekly chapel.
- Hope journals.

In the words of our children:

"Our ideas are not just heard but listened to in our junior school, and then our ideas are allowed to come to life" – Maria, Year 4.

"Kindness is the way we should live. It should be a global form of communicating joy and love through actions" – Melanie, Year 5.

Balancing act: understanding and planning for student wellness

KATHRYN ANDERSON

I have been looking at a wellness programme and implementing that in our school. The idea started in conversation prior to the pandemic, but of course what I had planned and what I was able to make happen were very different.

I will explain a little more about four areas: the "why" behind examining student wellness, the daily practices and plans that we individualised for students, my findings thus far, and finally the next steps.

I work as the director of student life and I had noticed in our school, Holy Name of Mary College School, just outside Toronto, Canada, that there were definite ebbs and flows for girls, whether in academics or in co-curricular life; there would be times in the year when they simply wouldn't be able to handle it all. I wanted to tailor a programme that would allow students to recognise their strengths and gifts and what they could do to keep moving forward. It was about personal accountability and putting balance at the forefront, not just saying, "Everything is going OK" and nodding.

I wanted them to look at why they are saying yes and what they are saying yes to, then setting out concrete plans for themselves that allowed for success in the end. The pandemic then struck, we were in trauma and we

had very strict rules. We went back in the fall with all these ambitious plans, and then around Christmas time we had those opportunities removed as we headed back into a lockdown. I worked with students from grades 8 to 11 (ages 14-18) and I had eight students in total, two from each grade. I had initially planned to introduce a school-wide project, run through a teacher adviser programme, but that had to be scaled back.

I had one-to-one sessions with the girls to establish their personal interests, what they liked and what was going well for them, and then worked alongside them to come up with some really strategic ideas that complemented what they were already doing. It was not an add-on or additional work, but meant to foster their development and understanding of who they are and how they might best achieve their success. We looked at silencing those parental views about what their children should be doing and focused on what they intrinsically wanted to achieve.

I read a great deal about the idea of saying no and how women leaders find it hard to say no sometimes. Personally, I find it hard to say no to students and staff within my school, so it was a good practice for me, and then to help young people look at that too and see what it is possible to do and feel positive about at 16. Kathryn Lively, professor of sociology at Dartmouth College in the US, talks about slowing things down in order to be able to find mechanisms for yourself that allow for success, and allow for you to say yes to things without that sense of burnout or feeling that you did not do a good job in the end. This came through in conversations with the girls – they were saying yes to everything without being able to identify what they were doing well.

We have a student guidance programme in school, called My Blueprint, which is similar to this. It opens with an inventory of who they are and so we started this project there. We know our students in our context, but who are they in a deeper way? We looked at what they felt their strengths were and then what they actually might be, what their interests were and then how these might be addressed based on their personality type. We identified their goals and made a template where they identified what their goals were in doing this project and what barriers they felt there were.

The students were very honest about what they thought they were not doing well at, some to the extreme, and conversations were had about why they felt that way. Based on those conversations, we came up with the next steps: we spoke every fortnight and I assigned them different tools and strategies from the bank that they could choose and try. Some they hated and some they loved!

For six months, both online and offline, we met to discuss these. They would try the activities and keep a log, so that we could come back to the strategies and discuss whether they were working for them or not.

The adaptability and maintenance of the programme was important too. It is great to trial new things and add them into the day, but the idea was not that it was an add-on; it was authentically part of who they were in their learning.

We learned that this approach is really hard work! It is hard as adults to prioritise things when we are busy, and as students there are peaks in the year. How do you carve up the time to ensure that you are well enough to continue putting in the effort that you need to? We discovered that consistency was the number one thing – holding yourself accountable and making sure that you did it every day for the fortnight mattered the most. Then, practising: starting the programme and then repeating this approach over and over again to find out what worked for them and what didn't was important. Several students changed their preferences as they went through the programme, altering what actually worked well for them versus what they thought they would like. Accountability was helpful – knowing that they would be checking in every fortnight and knowing that others were doing the programme too. The idea of a student mentor or buddy system where they could hold each other accountable rather than working with a teacher, for those more comfortable working with another student, was great feedback resulting from this trial.

The top five activities were:

1. **Bullet journalling**. Always a favourite, as it takes students away from homework to write random lists such as top 10s or what was on their minds at the time, which they found really helpful.

2. **Gratitude exercises** sounded cheesy to the students when first introduced, but with practice they learned to be grateful for themselves and even for things that didn't go well in the day.

3. Some loved **five-minute yoga** or another physical activity.

4. Another fun activity was **record and delete** – students would record whatever was on their minds and then delete it, which was very cathartic.

5. Finally, we had what we called **free choice** – they could take five minutes to do anything they liked, but it could not be related to social media. We had a lot of conversations about how social media should not be a barrier in their mental wellness – this was about an unplugging time to carve out for themselves.

Over time, **engagement** was at the forefront – students felt that they could do it all or that they wanted to do it all. Taking the time for themselves allowed for that to happen. There was a great sense of **ownership** too – that it was something they were in control of, when often girls can feel out of control in those "peaks", so helping them feel grounded was great. Then teaching them to be **self-motivated** – teachers will not be there forever and their parents will not always be giving them those daily reminders. It was good that this intrinsic self-worth and self-motivation came out of this work.

We, as educators, teach curriculum and do many amazing things with the girls, but there is also a responsibility to teach students about wellness. And not just to add it into a programme in our school, but to look at personalised wellness and what that looks like moving forward. There are so many pressures in society now; I dread the thought of having to go back and be a kid in these times. There is a lot of value in us helping our staff and our schools become advocates for this approach; teaching girls to be able to focus on their own journey and what is happening with them, not their friends. They need to take the time to practise these approaches and consider what went well and what might be improved.

There will be a new iteration of this in the fall, which we are rolling out within our teacher adviser programme. We will be developing personalised wellness profiles for the students alongside their academic profiles, and there will be school-wide activities such as targeted

speakers. We will also use a dashboard on the school management system so that students can track their own self-care and wellness – to see their strengths and when they are not doing the things they need to do. This means that when we are having our fortnightly conversations, they can be far more targeted.

I am grateful for the conversations that have come from this work. The landscape of education has changed so much as a result of the pandemic and it has been great to see how we can best support girls in these times.

From anxiety to empowerment: how can we build academic buoyancy in Year 6 science students?

CATHRYN FUREY

At Ruyton Girls' School in Victoria, Australia, we commenced our Anxiety to Empowerment research and action plan in 2017. Over the past five years we have collected quantitative and qualitative data related to academic worry, making sense of the collected data with student, teacher and parent groups. This student voice data has supported our staff to work collaboratively towards an informed understanding of the cultural forces and school-based processes and structures that contribute to our students' academic worry.

We know from previous data collected from Ruyton students through the Motivation and Engagement Survey (developed by Andrew Martin of the University of New South Wales and available from www.lifelongachievement.com) that academic worry increases significantly for students as they move through the final years of primary education (Years 5 and 6) and in the first three years of secondary education.

Academic buoyancy is one of relatively few areas in which gender differences at school are not in favour of girls. Studies by Andrew Martin and Rebecca Collie (University of New South Wales) have revealed that female students are significantly less academically buoyant than males and that academic setbacks register more and linger longer for girls.

Academic buoyancy refers to the ability of students to successfully deal with the everyday academic stresses of school life, such as missing an assignment deadline, catching up after an absence, or the unexpected change of a teacher. Students who are academically buoyant are shown to be able to successfully handle day-to-day academic challenges, difficulties and setbacks. They also demonstrate higher levels of motivation, engagement, wellbeing and achievement.

Our current interventions are focused on wellbeing, and particularly in teaching what is called the buoyancy cycle (Martin and Burns, 2014; Martin et al., 2013).

1. The student is taught how to recognise academic adversity (give examples, talk about it when it happens and when it might happen).
2. The student adjusts their cognition (thinking), behaviour and/or emotion to navigate the adversity.
3. The adjustment helps the student deal with the adversity.
4. The student recognises the benefit of this psycho-behavioural adjustment.
5. The student continues to engage in cognitive, behavioural and/or emotional adjustment in response to adversity.

Research (Martin, Colmar, et al., 2010) has identified the five Cs of academic buoyancy as outlined below:

1. Confidence (self-efficacy).
2. Coordination (planning).
3. Commitment (perseverance – don't give up too early!).
4. Control (focus on what they can control rather than what they can't).
5. Composure (low anxiety – most significant for girls).

During 2021, a preliminary research investigation was undertaken as part of the Global Action Research Collaborative on Girls' Education to explore whether the explicit teaching of the academic buoyancy cycle could strengthen problem-solving and academic risk-taking in Year 9 and 10 girls in a science elective. Initial findings indicate improved awareness, commitment, coordination and student agency in

the students who were explicitly taught the academic buoyancy cycle. Students particularly identified that they needed these strategies much earlier in their schooling – and they suggested Years 6-8.

The research focus in 2022 has been to explore the impact of explicitly teaching one of the five Cs of the academic buoyancy cycle (commitment, otherwise described as perseverance) to younger students (Year 6) in the science programme. This research involves:

- Pre-survey of students regarding their understanding of what perseverance in learning means and what their current approaches are.
- Explicit teaching of strategies to increase their perseverance.
- Students completing a design thinking task that requires them to develop an initial design for a wind generator, then test, refine and improve their design through an iterative process.
- Post-survey and focus groups with students to measure the impact of the explicit teaching of strategies to build perseverance and student commitment to the task.

This research has occurred as part of a wider year-long focus of our Teacher Inquiry Group, working with a team of staff from across the school, supported by our research lead. This wider project has included the development of a set of resources, accessed via our intranet, to support students.

Following the initial survey for baseline data collection, students undertook an introductory session exploring commitment. Students were actively engaged and very keen to provide examples of how they persevere and problem-solve. Students were then allocated groups (adding another layer to academic buoyancy) and asked to design and build a wind generator that would operate with a hairdryer to lift a cup of weights. Over a series of four lessons, the students reiterated, tested and revised their models. At the start of each session, we explicitly reviewed the key ideas relating to perseverance and revisited the resources that the students could access on the intranet to support them in the project.

When the project was completed, students posted a video of the wind generator on Seesaw (the continuous reporting platform used across our junior school) and answered three questions:

1. What am I most proud of?
2. What was our biggest challenge and how did we overcome it?
3. What strategies did we use to persevere?

Students repeated the same survey they had undertaken prior to the project. Of particular significance is the change in their responses to the question: "When I try to solve a problem, I am willing to explore different solutions, test them out and learn from my mistakes." The proportion of students who said "definitely true of me" or "somewhat true of me" increased from 77.2% before undertaking the project to 94.4% after completing the project.

Next steps in this research journey will be to redesign the research so that students complete a problem-solving task and then do the pre-survey, cover the "academic buoyancy" focus and then undertake a similar task. It is our hope that this will provide more meaningful pre- and post-survey data. Later in 2022, staff working with Year 7 will focus on commitment in maths, while those in Year 8 will focus on commitment and coordination (planning) in history.

The focus of our ongoing school-wide approach is empowering our girls to best navigate this world they occupy. Through our wellbeing and learning programmes, we continue to support them with a specific focus on the cultural force of language, messaging around stress, anxiety and worry, and explicit teaching of the academic buoyancy cycle.

Bibliography

Martin, AJ and Burns, EC. (2014) "Academic buoyancy, resilience, and adaptability in students with ADHD", *The ADHD Report*, 22(6), 1-9

Martin, AJ, Colmar, SH, Davey, LA and Marsh, HW. (2010) "Longitudinal modelling of academic buoyancy and motivation: do the '5Cs' hold up over time?", *British Journal of Educational Psychology*, 80(3), 473-496

Martin, AJ, Ginns, P, Brackett, M, Malmberg, L-E and Hall, J. (2013) "Academic buoyancy and psychological risk: exploring reciprocal relationships", *Learning and Individual Differences*, 27, 128-133

Pedagogy and curriculum

Embracing individuality: how do we find a way of increasing understanding and acceptance of neurodiversity and hidden differences within our school community?

CLARE DUNCAN AND ISABELLE ALEXANDER

At Wimbledon High School in London, UK, we developed a project with an aim of shining a light on neurodiversity and hidden differences; we wished to build awareness and acceptance. Conditions such as autistic spectrum condition (ASC) and attention deficit hyperactivity disorder (ADHD) are generally still not openly discussed. As a result, people with these conditions often try to mask their symptoms in order to fit in with society. Dyslexia and dyspraxia/developmental coordination disorder (DCD) are better understood and yet the world can still be a hostile place for people with these differences.

In our school, we select students on the basis of their academic ability. Some of these students will have special educational needs – or, as we prefer to say, learning differences – identified either on admission or as they progress through the school. Our neurodiversity department colleagues advise teachers on strategies to deploy in supporting them. In reality, this can mean that teachers develop lesson plans for the majority

and then highlight what they will do differently with any neurodivergent students.

One of our key aims is to build an inclusive community. We want to promote a community where every student feels known, understood and heard; where every student can access the resources appropriate for them to achieve their potential, irrespective of their starting point; where all are treated equitably and are not seen as "other". We want to have teaching approaches that can reach all students, so they all have equal opportunities to thrive.

There was a strong feeling that we needed to hear the voices of the students. By listening and reacting to our young people, we can be part of the movement of change. We needed to enhance our understanding and knowledge of how school feels for them.

The idea was simple. Over a series of weeks, we would gather our neurodivergent and hidden-difference students, pool them into groups and get them to discuss areas that were challenging for them, to find out what the learning felt like. Then their voices could be shared to give the whole community (fellow students, teachers and parents) an understanding of how living and learning is for them – let them educate us. It certainly seemed simple… Well, those of you who have worked with pupils with ASC or ADHD will know that trying to get such students together in a room to talk to one another, and to us, is not as simple as it sounds.

It came down to trust. They trusted that we would make changes on the basis of what they said. They had a vested interest in working with us to be part of the voice of change within the school.

Our first step was not only listening to them but capturing their thoughts and feelings on a video that we could share with the community. Initially, it was shown at a whole-school assembly. The students express themselves on film – some in animation form with a voiceover, so their faces did not have to be shown.

All this struck fellow students and teachers powerfully, making them realise how individuals – friends, peers, students they teach – can be experiencing something quite different within the same class. It was personal; suddenly there was a greater understanding.

The reaction was incredible. It gave more confidence to our neurodivergent students and those with hidden differences, as they started to feel better understood. They don't want to be classed as "other" – they are just another student in the class with a different set of needs.

The video opens with music played by a student with a sight impairment. Through a series of sketched images, one neurodivergent student states: "I am autistic. For me, that means a special relationship, an interest, with words and language." This student goes on to describe how learning feels for her. She takes longer to form sentences and translate her thoughts into speech because she needs to order the words in her head before she can say them aloud. She goes on to say, "This doesn't mean I don't know what to say, I just don't know how to say it." Her final comments are, "This is just a part of who I am. We are all different and we should embrace this fact without judgement." There are also insights from students with dyslexia, ADHD, sight impairment and hearing impairments.

The impact of the video was immediate. We run a regular parent forum. Without prompting and without having seen the video, parents started talking about the impression it had made on their daughters and how conversations about these conditions had opened at home: change was starting to happen.

The students involved also gave a presentation to the senior management team where they included how they felt in the classroom. Some of this was quite hard-hitting: they felt they were treated as "less than others"; they did not always feel respected; they were only identified by their struggles and not as a person in their own right.

They requested changes to lessons that would enhance their educational experience. Within lessons, their wish is for all teachers to take more pauses and to have some quiet reflective time. Clear, concise instructions – not only spoken but written down for reference to stop them feeling left behind – are preferred. They asked for non-shiny tables; for lights that are dimmable. They very firmly asked not to be singled out. And if a teacher goes "off topic", this can be confusing; simple signposting can make a huge difference.

There was a strong message that the community needs further education but, in doing so, those who are neurodivergent must not be left feeling

patronised. Their plea was for involvement from people who have lived experience, rather than from the "experts" in the field. As such, we organised other activities.

A mother and daughter, both with ADHD, came to speak about their experiences. They were with us for the whole day, delivering a PSHE session to students, a training talk to teachers and finally a session for parents in the evening.

Student view

"I am autistic. For me, this means a special relationship and interest with words and languages. I would like to talk about my experience. I take longer to form sentences and transfer my thoughts into speech, because I need to order the words in my head before I say them out loud.

This doesn't mean I don't know what to say, I just don't know how to say it. The thought in my head is mostly made up of words and images floating around, which I need to ground and place into coherent English before speaking. If I say what passes through my head, no one will understand the few completely unrelated words I just said. So I have to completely pre-prepare my sentences, otherwise I don't make sense.

I often get overwhelmed, whether it's due to asking to fit in; whether it's due to bright lights or lack of control. I become anxious, my attention becomes fragile and the words in my head float away and I'm left not knowing what to say. I sometimes resort to gestures or just single words.

I am a pattern and verbal thinker; I love words and finding patterns, especially in verbal speech and across different languages. Contrary to popular belief regarding autism, I really enjoy writing and it makes me feel safe, because not only can I express myself better this way but everything makes more sense to me written down. This is just a part of who I am. We are all different and we should embrace this fact without judgement."

During Autism Awareness Month, two young professional working women visited us and described what their life was like living with autism.

Our Year 9 dyslexic students delivered a talk on dyslexia to Year 7 students.

An alumna came to talk about coping with a stammer, as part of a pastoral day for Year 7.

Student view

"We have ADHD. I think it's weird when people ask us what it's like to have ADHD because we don't really know anything other than our perspective. So we can't really explain it to other people who don't think in the same way. To explain it to them, you'd have to explain what it's like from the perspective of someone that doesn't have ADHD, but we do have ADHD so we don't know what their perspective is like. It's hard for us to explain it to them in a way that they would understand.

We both have the combined type of ADHD, but there are two other types where it's primarily hyperactive and primarily inattentive. We're both, like a mixture. Because we're impulsive, we get into trouble a lot at school. We might say something rude or we might do something wrong, because a lot of the time we do stuff without thinking it through first. It's like there's no filter that stops what you think about what you're about to do. Something pops up and you just have to do it.

People assume that ADHD is more of a thing that boys have than girls. There's a harmful stereotype about ADHD being just boys, and just people who are young – that you grow out of it, which hasn't happened. It's harmful because ADHD becomes under-diagnosed in girls and there are a lot of women not getting diagnosed until later, so I think it's important that we bring more awareness and understanding so that it would be less of an issue in the future."

We also held a "question time" where a panel of students with hidden differences answered questions that teachers raised (sent in advance). Bravely and openly, they tackled questions such as:

- How can teachers make your school experience better?
- What is the one thing that teachers do that annoys you the most?
- How do different environments (e.g. swimming pool and astro surface for games) present different challenges?
- How can we make the help subtle?
- How do you feel about going to university/the workplace with a hidden difference?

Student view

"Many of you know me: I am all over the school like a rash, to quote Mrs Alexander. I play piano and various other instruments which shall not be mentioned. I garden, I wear sunglasses, I want to be the next David Attenborough. I did archery and I am also sight-impaired. I have a condition called Stargardt's, which means there are a few things I can't do, such as hit a shuttlecock when it's hit at me at 50 miles an hour at my face. Trust me, it won't happen! But please don't assume lack of ability, as someone from Merton once did. I certainly put her straight but it wasn't a nice experience.

Anyway, I see through my peripheral vision because my central vision is virtually non-existent. Which means, going back to badminton, when a shuttlecock is flying towards me I see it a couple of inches away from where it actually is, so this leaves me waving my racket like a maniac trying to hit the shuttlecock when it just won't happen. But I can serve quite well considering the odds. Seriously, though, it does pose its challenges. But I'm very grateful to have friends and teachers who help me so much."

We are only on the start of our journey of increasing awareness, understanding and acceptance. We will continue with this. Our students' voices will continue to be heard and listened to as we work towards a truly inclusive community.

To finish with the words of one of our autistic students: "Seeing things differently can change the world."

Student view

"I have recently been diagnosed with autism. For me, it was a relief as I had felt different in some way, but I never knew why or how. When I got my diagnosis, I knew very little about autism. I had only seen an extreme portrayal of it: toddlers seemingly misbehaving in the supermarket and parents unable to cope. However, I now understand that autism encompasses many different qualities, such as alexithymia, not just the obvious ones. It is nuanced and complex and different for each individual. It often presents differently in girls and is far less known about. Seeing its depiction in media is disturbing for me, as it does not give the full picture of autistic people as human beings with varied traits.

It was harder for me to realise I was autistic as I didn't match these stereotypes. They give simplistic, polarised images of either a savant genius or an infantilised individual who can't function in society. These negative stereotypes scare some people [off] being open about their diagnosis. The media portrays autistic people as a burden to their families and society. We are not burdens: our brains are just wired differently and we think differently to neurotypical people. Being different is not negative. We can contribute greatly to society. Seeing things differently can change the world."

Mastery-based learning and an examination of change management

KATE BANKS AND ELLIE PEAKS

Kate Banks

Back in 2019, in my school in Melbourne, Australia, we introduced a signature programme called KXP Expedition Learning. It is an eight-week learning expedition, founded on curriculum outcomes across a number of different learning areas, and has the three dimensions of building character, mastery of knowledge and skills, and creating high-quality work.

The research behind the project looked at the definition of mastery learning:

> *A way of designing units of work so that: 1. each task (or set of tasks) focuses on a particular learning objective; and 2. the students must master a task in order to move onto the next one.* (Australian Education Research Organisation, 2021)

The Education Endowment Foundation (2018) suggests that students "must demonstrate a high level of success on tests, typically about 80%, before progressing to the next unit" and that mastery learning may be "more effective when used as an occasional or additional teaching strategy: programmes with durations of less than 12 weeks have tended

to report a higher impact than longer programmes". The EEF also says that "additional small group tuition and one to one support are also likely to be needed for those pupils who take longer to learn a topic" and that "teachers need to plan carefully for how to manage the time of pupils who make progress more quickly".

Based on my research, I felt that mastery learning was a very exciting and valuable tool to use. However, I was unsure about how I would balance the fast pace of my school context with students not moving on from a skill or learning objective until they had fully mastered it. I was also mindful of the practical element of needing to manage the classroom environment and cater for all students when they are working at different stages.

Towards the end of my research, I came across Kieran Mackle's podcast *Thinking Deeply About Primary Education,* where Matt Swain was interviewed about his school and how they adapt to mastery learning. This led me to very practical ways to introduce mastery learning into my school context.

I introduced the basic "I do, we do, you do" structure. I give explicit instructions for 5-10 minutes with lots of examples. We then go through a variety of well-chosen examples together (15-20 minutes). Students then work in pairs following the "think, pair, share" idea of one student answering a question and explaining to their partner what they did as the teacher circulates. Students then work independently as the teacher moves around the room, marking work and noting misconceptions. The teacher can work with a small support group for students who need it, or there is the opportunity to go deeper into the concepts.

I enjoyed the fact that I was able to track student progress really well and give support to those students that needed it. I found it a little challenging that I implemented this at the start of a school year when I did not yet have a clear idea of my students' ability. I then discovered that I had a large number of high-ability students, some of whom were working two or three years above standard and needed things to move at a faster pace. As a result, I adapted the model to give students a choice after the "I do", to let them decide whether they wanted to move straight into the independent work and then an enrichment activity, or whether

they would rather stay with me, working through more examples. This really helped all the students in my class.

I also experimented with implementing a mastery week, which came from some conversations I was having with our science department, who were trialling mastery learning within their discipline. It started with a mini quiz at the beginning of the week where I could assess any gaps in learning, and then students were provided with revision and extension tasks throughout the week. I was able to run workshops with those students who needed extra support and those who needed extension. Their post-assessment was at the end of the week.

The student feedback was positive at the end of the week: 87% of students responded that they enjoyed having class time to revise before an assessment and felt they had a clear understanding of what skills they needed to work on. Interestingly, only 67% of students wanted to see the result of their assessment and to go through the test with their teacher, and only 13% said they would take up the opportunity to resit an assessment to make improvements. That tells me that I need to do more work with my students around the concepts of feedback and mastery, and how they take on feedback to improve.

In terms of next steps, I want to continue using mastery learning within my classroom, but I want to include more points in my lesson structure to check for understanding. This might be something as simple as "cold calling" and then adapting my teaching according to the responses. I intend to introduce daily revision of past concepts to check if students have forgotten topics that then need revising. An area that we discussed early in the project was the idea of student agency, which is the next area for me to work on: to get students more involved in their learning so they have a clear idea of what their goals are and how they are going to work on them. Throughout the unit, I would encourage students to offer evidence to demonstrate that they have achieved their goal, so they can move on to the next one.

In a bigger-picture context, we probably need to review our formal assessment processes within the school, looking at how these can be adapted to reflect the concepts of mastery learning. Would there be the opportunity for a written report comment on students' work where they

had had the opportunity to resit, for example? We could also look at rolling this out across all years and all subject areas.

Ellie Peaks

I am the assistant director of co-curriculum at the Madeira School in McLean, Virginia, US. The co-curriculum programme is an internship programme in which students in the 10th, 11th and 12th grades are paired with a five-week internship during the school year. I have a different entry point to this mastery-based project as I don't work directly with students daily in a classroom, but I do develop curriculum and grade assignments for a graduation-required course. Kate and I discussed how difficult it is to implement such a large change into our own classroom, and what a larger shift still it would be to implement into classrooms beyond our own. It occurred to me to take a management lens to look at this issue as a change-management consideration. So, I decided to look into this larger topic. I know people familiar with working in schools will be used to change – it feels as if there are newer and better ways in which we could be doing things. That is an exciting and engaging concept for some, but sparks frustration and anxiety for others. With all this in mind, I wanted to examine a few different tools and theories that exist to help us manage change in an institution such as a school.

I looked at three main categories and pieces of work:

The Quality School: managing students without coercion by William Glasser. He looks at **choice theory**: "Every individual only has the power to control themselves and has limited power to control others." This clearly has implications for working in a school with students, but also with adults. Glasser talks about how we all have five basic needs – survival, love and belonging, power, freedom, and fun – and that "our behaviour is always our best attempt at the time to satisfy one or more of these needs". He emphasises the need to strip away any adversarial relationships between teacher and student as you move towards change of any kind. He talks about the "quality world" where "we learn to remember all that we do, or all that happens to us, that feels very good. We then collect these very pleasurable memories into what is best called a quality world, and this memory world becomes the most important part of our lives." So, the key here, when looking at change management, is

to consider what picture we could build of what we are trying to achieve that might live in the quality world of the people charged with carrying out that work. If people don't have good experiences of change or good experiences of working with the people implementing the change, it is going to be very difficult for them to build that into what it looks like to feel good in their work. This includes empowering people, through conversation, to discuss the issues that they foresee, rather than brushing concerns aside as you move through this process of change.

The second point is about **avoiding coercion.** "In a quality school no attempt would be made by the administration to coerce any teacher into making this change until he or she was ready," Glasser writes. "There is a big difference between a benevolent boss and an actively helping and facilitating leader." Glasser points out that big and small coercions – which many people do not notice, as it is the way schools traditionally run with both students and staff – work against the goal of building a quality school with people dedicated to doing quality work. So, if people in school are not early adopters of change, it is worth questioning what spoken or unspoken coercions might be being used that are aimed at getting them in line, instead of working with them to get to a point where everyone can see how a change might satisfy one of those basic needs at work. This is so much easier said than done, particularly when people have different histories of working with the hierarchy within a school, and also the connection or disconnection between what people say, what they mean and what they do.

Glasser's book speaks to the mindset that any leader needs if change is to endure in a school. After I had read this, I thought about how schools can be friendly places but still have these spoken and unspoken coercions to keep people moving in the right directions. Supervisors can still be kind and benevolent while being coercive in the way that they manage. Implementing change can be riddled with coercing people to get in line with the change. It gave me a great deal to think about in terms of what foundational philosophy is necessary in rolling out a new programme and having it feel good for those working with it.

I then looked at the **concerns-based adoption model** (CBAM), which is directly related to change management. The research I conducted on this

was largely within the Southwest Educational Development Lab (SEDL). This CBAM model was developed in the 1970s and 80s and is one that leaders of organisations can use to understand, monitor and guide the complex process of implementing new and innovative practices. It is not specifically geared towards schools, but its components really map well with any institutional change a school might wish to make.

It has three main components. The first is **innovation configuration maps**, which are the rubric or "picture" of innovation to guide successful implementation. This helps avoid the situation where people leave the training with different pictures of what the school is trying to achieve in the classroom. It is very helpful as an ongoing tool to inform what personal development or training might be needed and where everyone is landing right now, as the institution is moving towards the effective and successful implementation of the programme.

The second component is **stages of concern**, which is a survey that captures reactions to an innovation (George et al, 2006). These are feelings and attitudes that, while the phrase "stages of concern" might make you think of anxiety and frustration, are not always negative. The survey seeks to discover how people are feeling about a new change. It can be good for supporting individuals, if that is the type of data you wish to collect, but it is also good at tracking data to establish where a team or department within the organisation is as you move through the change process. For example, the science department might be struggling with the change but the history department are all on board and moving forward.

Finally, the third component is **levels of use**, which is similar to stages of concern as it is a survey, but it focuses on the level at which people are implementing the new change. In other words, you can establish whether an individual is still learning about what the new change is, all the way through to synthesising at the top. It is rather like a Bloom's taxonomy of use and innovation, and it captures how well and how thoroughly people are working with the new approach. Again, it is useful as a data-gathering exercise but also in instructing you on the next steps, such as what might be taught in the classroom. You need a finger on the pulse of the change for individuals and the organisation to know what might be needed to support a move to the next step.

This model seems very useful, as it gives strategies, protocols and structure to a process that can involve so much professional and personal turmoil for people and organisations as a whole. It brings some objectivity and data into the process. But, that being said, data can be scary for people – it really depends on the culture and attitude of the individuals and organisation. It can be feared by others, thinking this is a way in which they will be assessed and judged, rather than simply that "the more data the better" as it gives us information. Just like any other aspect of a fulfilling and engaged life in the workplace, trust is required when it comes to this issue.

The last piece of work I looked at was about **restorative practices**, and is something that we have begun some training and thinking on in my own school this year. The research I did was based on work from the International Institute for Restorative Practices (Wachtel, 2016), which is rather like a grad school where you can study and get a degree in restorative practices. It has its roots in restorative justice, which was focused on the criminal justice system and had the goal of repairing harm done to people in relationships, rather than purely punishing offenders. The concept then grew to see applications in other communities of care, like schools. It relies on community and relationship building as the foundation for improving behaviour, providing effective leadership and navigating challenges and conflict, which often arise when change is coming for an institution. There were two supporting frameworks that really stood out for me.

The first was the **social discipline window**, with the tagline "This is how we lead". It can be thought of as axes labelled "support" and "control", from low to high. When there is low control and low support then we are in the "not" quadrant, where we are ignoring something, neglecting something or leaving something completely alone. When support is low but control is high, things are happening *to* people and it can often feel punitive. When high on support but low on control, you are doing something *for* someone, which is very permissive and does not have high expectations along with it. The goal is to live in the "restorative" quadrant, where you are working *with* people to give a high level of support, but also a high level of control in terms of limit-setting and setting expectations. This concept seems important as so often change

management can go sideways when it exists outside the restorative quadrant. Being in the restorative quadrant, emphasising high levels of expectation and support, is important when implementing something new for it to be successful, as it allows everyone to feel part of the process and supported along the way.

The second framework is called **fair process**, with the tagline "This is how we engage". There are three steps to use, based on this idea that when authority does things with people the results are better. The main concept is that individuals are more likely to trust and cooperate freely with systems, even if they win or lose by those systems, when these steps are observed.

The first step is **engagement** – involving individuals in decisions that affect them by listening to their views and genuinely taking their opinions into account. We have all been in conversations where we have shared our views but then it doesn't seem to go anywhere, so that engagement piece needs to be authentic. The next step is **explanation** – once a decision has been reached, explaining the reasoning behind a decision to everyone who was involved or affected by it, so that they can understand it. The last step is **expectation clarity** – making sure everyone clearly understands not just the decision but also what is expected of them in the future. Restorative practices relate to working with students and all different members of the community, and have a great deal to do with making people feel valued and a part of the community. A big basis of it is having the relationships on which you can build and possibly have difficult conversations, so there might be quite a bit of groundwork to do there, too.

In conclusion: change is important, complicated and personal to individuals. One of the main responsibilities of our leaders is to guide institutions and groups through change. In working on this, I spoke to a number of colleagues about their views on change and something that came up frequently was the idea that "We go faster alone, but we go further together". This really stayed with me as we thought about navigating this change of mastery learning with our groups.

Bibliography

Australian Education Research Organisation. (2021) *Mastery Learning: know how to make sure your students learn,* www.edresearch.edu. au/sites/default/files/2021-03/AERO-Tried-and-tested-guide-Mastery-learning.pdf

Education Endowment Foundation. (2018) *Teaching and Learning Toolkit,* https://educationendowmentfoundation.org.uk/public/files/ Toolkit/complete/EEF-Teaching-Learning-Toolkit-July-2018.pdf

George, AA, Hall, GE and Stiegelbauer, SM. (2006) *Measuring Implementation in Schools: the Stages of Concern questionnaire,* SEDL, https://sedl.org/cbam/socq_manual_201410.pdf

Glasser, W. (1990) *The Quality School: managing students without coercion,* HarperCollins

Wachtel, T. (2016) *Defining Restorative,* International Institute for Restorative Practices, www.iirp.edu/images/pdf/Defining-Restorative_ Nov-2016.pdf

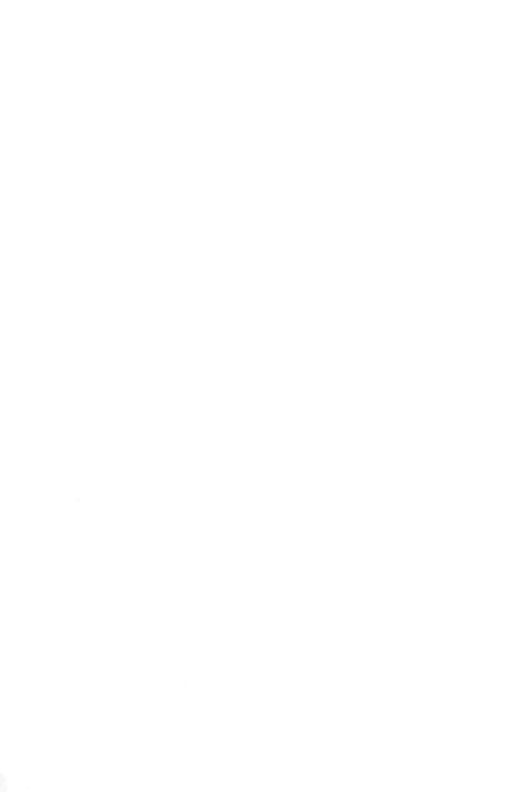

Reflections on environment and sustainability across continents and through different curriculum areas

TARA QUENAULT AND SUSANNA LINSLEY

Tara Quenault

I'm going to tell a story about our collaboration, what it did for our students and what it did for us, because it's been a really rich learning experience for the two of us in our teaching practice, but also for the ways in which we are engaging with our schools. We are looking at environmental sustainability across our different curricula.

I'm a chemistry and science teacher and I also teach English. I have a special interest in interdisciplinary and looking at connections between different disciplines. I'm head of science at Melbourne Girls Grammar, Australia, from grade 5 to Year 12. Suzi is director of experiential learning and a teacher in the humanities programme at the Webb Schools in Claremont, California, US.

Both schools are girls' schools with an academic focus. The kismet of our partnership was really interesting for us as well. When we first met, we realised that we were both reading the same book: *Braiding Sweetgrass: indigenous wisdom, scientific knowledge, and the teachings of plants* by Robin Wall Kimmerer. We were both about to build brand new courses in our

schools. We had a shared interest in environmentalism and sustainability. We found that our students had particular concerns, climate change being one. We wanted to see and explore how we could build this into our courses in really authentic ways – mine in the science area and Suzi's in the humanities and literature area – but also how our different areas of expertise could enrich what we were doing. So we were looking through different lenses: scientific, literary, sociocultural, environmental, and others.

That's where our conversations began: sharing reflections on our reading, the different texts that we were exploring as we were writing these courses, and our different areas of expertise. The past six months have been our conversations, as we implement the courses in our current environment – this unprecedented environment with all the associated obstacles.

Our early prompts were around sustainability and the serendipity of two courses springing to life at the same time. We really wanted to explore the students' curiosity and the wicked questions that they have around this area. They have a baseline understanding of what is going on in the world. They access their information in different ways, through social media, whatever news cycles they are engaging with, through their friends and at school as well. So we wanted to incorporate that into the ways that we were designing the courses, with embedded ethical understandings and a central perspective of moving away from an anthropocentric approach to learning about these topics to an eco-centric approach.

What we wanted to do in the science course was to create a narrative approach to designing the courses and then fit the curriculum key knowledge and skills as appropriate to the story. The lenses were physical, chemical and biological sciences, with the idea that we were telling the story across the semester through the different disciplines, and the skills and the curriculum fit where appropriate. A team of five teachers worked on this for seven classes, with a focus on parity and low variance in the opportunities students were given through the learning.

Suzi's situation was slightly different: one teacher and one class, allowing for more flexibility and responsiveness to student perspectives.

The themes of my course were the origin of the universe to the age of the Anthropocene (quite a lot to cover in six months) including Earth and the conditions for life in our position in the universe.

Suzi had a similar thread running through her course. She began with nature writing, went to food systems, and focused on the Anthropocene and its origins (the last 10,000 years of human history). I tried to cover 13 billion years. We noticed as we came more into the same part of the historical timeline that our collaboration got even richer, because we were talking about similar readings and could focus on our move from anthro- to eco-centrism.

During the course the students brought the following graphics to my attention, which did the rounds on social media at the same time as the Intergovernmental Panel on Climate Change report came out. The graphics have been updated quite consistently through our partnership (see www.climate-lab-book.ac.uk/spirals), so we have a lot more to talk about in terms of future perspective and global understanding. The graphics (below and on the next page) show the global temperature change between 1850 and 2020.

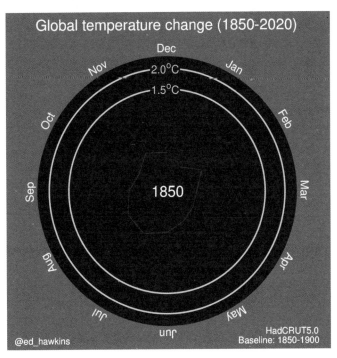

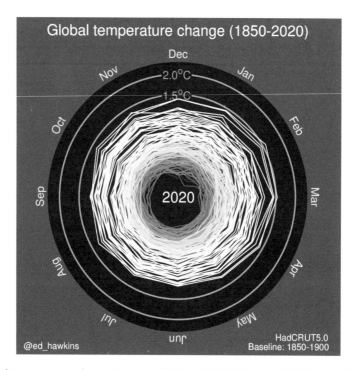

Global temperature change between 1850 and 2020. Source: Ed Hawkins/ www.climate-lab-book.ac.uk

My background in science helped Suzi to position her literature and humanities course with that core understanding running underneath it. And, conversely, her experience in literature and humanities and reading and the different ways to engage with texts and other perspectives helped me to reimagine how we might teach science and help students to engage with these ideas in meaningful ways.

The key connections for us (see table opposite) were the collaboration across disciplines. We both learned so much about how we could cater to the students' interest and need, but also about our teaching practice, enriching each other's understanding of these thematic threads across the curriculum. And also the enhancement of transdisciplinary understanding and how we can introduce these in both core courses in a curriculum – how we can run a thread through in a meaningful way, not a tokenistic way, that shows students how these ideas and disciplines are connected.

Sustainability Venn diagram

Reflections on environment and sustainability across continents and through different curriculum lenses

• Level 10 core science programme. • Five teachers and seven sections. • Required to meet state standards. • Curricular requirements to building competencies in physics, chemistry and biology. • Less flexibility and responsiveness. • All topics used the framing of chaos and stability, the origins of the universe, highlighting the way all environments change over time, science writing and communication. • Urban environment. • Lead teacher had a background in science and English and was the science department chair.	• Humanities lens allowed both courses to weave in poetry and raised questions about the relationships among humans and nature, building in space for personal reflection and encouraging students to build their own relationship with the Earth. • Science lens gave both courses a focus on the origins of the Anthropocene and its consequences, following geological time. • Both courses asked students to become articulate and informed advocates for climate justice. • Both courses asked students to practise making arguments using a combination of literary and scientific sources.	• 11th and 12th grade humanities elective class. • One teacher and one section. • No required state standards. • Curricular requirements to build competencies in critical reading and writing. • More room for flexibility and responsiveness. • Main topics included nature writing, food systems, the Anthropocene and its origins, climate justice and eco-literature. • Suburban environment. • Lead teacher had background in history and English and was the director of experiential learning.

We created two new sustainability courses, successfully implemented during a very challenging six months. We have evaluated each other's courses and suggested ways that we could refine and improve the delivery and operation of those courses. It was a really exciting thing to be able to do for each other.

The friendship we developed and the collaboration and support we could offer each other has just been wonderful. I always looked forward to my

meetings with Suzi, always a flow of emails a day or so later as we had time to reflect. For us, it has been a really rich experience.

For our students, what we have started to do is to break down the dichotomy between the "natural world" and the "human world" in two very different disciplinary spaces. The students are now more aware of their position in the universe, on Earth and as part of nature. They are more informed and articulate advocates for climate justice because of the exposure to the different texts that we have been able to give them. They can construct arguments about the current state of the planet, bringing together broad scenarios, scientific and literary evidence, and prose. They are better able to connect with who they are speaking with, using their writing to connect with the audience and show them the ways that climate change is affecting us personally but also on a global landscape. They have a stronger relationship with the Earth – as it was, as it is now and as we hope it will be.

I want to end on hope. We discussed often that Earth, the climate and humanity can be very demoralising to look at with the current state of… well, everything. We hope that have been able to do that with hope by following that eco-centric arc throughout our courses.

The impact on student perceptions when increasing immersion of community values and diversity

MICHELLE FITZPATRICK AND JOANNE WALLACE

Michelle: I have been head of technology and enterprise at St Mary's Anglican Girls' School in Perth, Australia, for over nine years, having previously taught in London. I have a deep understanding of innovative educational programmes and a desire to develop future-ready girls who exercise agency, with high levels of digital and data literacy. I've developed and led a highly successful in-house entrepreneurial STEM-based scheme for our Year 10 students called the I³ Program (interdisciplinary, intelligence and innovation). The I³ Program is in its fifth year, with over 1000 students having undertaken it, with nearly 400 industry mentors and guest speakers supporting us thus far. As a transformer, creative leader and passionate thinker, I view the Global Mentoring Network for Aspiring Leaders (GMN) as a way of successfully working with schools across the globe. I'd proposed to Ian Wigston that I'd like to work with an overseas high school to develop a real-world project solving a real-world problem and making a change in our world.

Joanne: I am head of pre-prep at Abbot's Hill School in Hertfordshire, UK. I'm responsible for the day-to-day running of the pre-prep and improving transition through to the senior school. I wanted to use the

project aspect of the GMN to see if what we do actually had an impact on the behaviour and views of the children.

Initial conversations

Michelle: Before I met Jo, I found out she was an early years leader. So I thought my initial idea might not work and started to brainstorm alternative projects with my team. Jo and I tried to devise a joint project that was collaborative and worthwhile over many virtual email meetings and discussions back at our respective schools.

Joanne: In September 2021, I took part in some professional development on diversity policy and inclusion at my school with the Schools Inclusion Alliance. A big aspect of this was looking at our children's inclusive behaviours, which were not as inclusive as we would like them to be. We felt we might be missing something – was there something we could do more of to assist this development in the children? I went back to Michelle and told her that I really did want to focus on diversity, equality and inclusion (DEI). Michelle agreed with this and agreed that we both needed to be happy with our projects. We were passionate about our individual projects, but we really did want to work together and support each other through this.

Michelle: As an Apple Distinguished Educator, I wanted to continue my focus on a STEM-based project. I also wanted to continue solving real-world problems, as that's an area that I'm passionate about. I tried to adapt my project to DEI, but my executive felt I was compromising my outcomes. In October 2021, it was announced to staff that the school purpose was "to engage hearts and ignite curious minds", and that the school's values would be courage, respect, aspiration, compassion and integrity. As the school would be launching the school values in 2022, I thought it would be more relevant to focus on the values and this was supported by members of my executive. I contacted Jo to discuss the idea of each of us doing our own action research project.

Action research project proposal: does increasing the diversity of our resourcing and messaging impact inclusive behaviours?

Joanne: The rationale behind the project that I wanted to focus on was: does increasing the diversity of our resourcing and messaging impact the

inclusive behaviours of the pupils? The perception of our staff was that we were diverse and inclusive – there wasn't much more that we needed to do. However, behaviours from the children did not always mirror this view. There was an undercurrent of exclusionary behaviour surrounding what people looked like, wore, did, or what was happening outside, particularly when children were playing.

For example, we have a playhouse and the children would exclude others from coming into the playhouse because of the colour wellies they were wearing, or if their hair was a different colour. In some cases – and this is where the concern came from – they would be excluded because of the colour of their skin. The project was formed to find out if, as a team working within the pre-prep, we could impact these behaviours. If we modified or changed what we did, would that have an impact on what the children did?

In order to ascertain the children's views on race, I performed the Doll Test on all children across the pre-prep, aged 4 upwards. I performed this in the third week of the academic year, in September 2021. This exercise came from attending a Schools Inclusion Alliance workshop with Claire Harvey [the Doll Test itself was developed by Kenneth and Mamie Clark in the 1940s].

The test was designed to ascertain young children's unconscious bias. On the table were placed two baby dolls – one White, one Black – and the children were asked to answer the following questions by pointing at one or both of the dolls.

1. Which doll do you want to play with?
2. Which is the nice doll?
3. Which is the bad doll?
4. Which doll is a nice colour?
5. Which doll is most like you?
6. So which doll do you want to play with?

The results from this were quite stark. On every question I asked, the children were biased towards the White doll by over 70%. This included children of Black heritage who would point to the White doll as the "nice doll" or the doll that is the "nice colour". The team within the pre-prep

were quite shocked by the responses of the children and were all in agreement that we needed to do more to address a clear bias among the children.

We had several meetings on how, as a team in pre-prep, we could impact this view – change this view. We came up with a range of actions:

- Increase the range of books in each classroom that feature different cultures, faiths, role models, family units and disabilities.
- Ensure our displays reflect diversity.
- Increase the resources in our early years settings to be more diverse (role play and small world).
- Ensure our art resources enable every child to represent their skin colour.
- Make curriculum changes to include a diverse range of historical figures (history), countries around the world (geography), current important figures (PE, science, PSHCE and DT), artworks (art) and texts (English).
- Ensure assemblies and messaging from adults are centred on inclusive behaviours.

In May 2022, to see if pupils' acceptance and views had changed, we repeated the activities to ascertain attitudes and behaviours. I did the Doll Test with every child who had done it in September. Had we made a difference to the children? Had we done a lot just by increasing our resourcing and talking about people in different roles and cultures across the world?

Across all the questions I asked, the children's views had changed for the better. The key points were:

- They were much more open to choosing a doll of a differing skin colour to their own.
- The children who are Black or have family members who are Black all chose the black doll as the "nice" doll and the "nice" colour.
- A significant number of children refused to choose one doll when asked a question. They opted for both.

When we reviewed the data from the second Doll Test, the staff were surprised that what on the surface were small changes had had such a big impact in just over eight months. We have now set up a school-wide DEI group to tackle this across the whole school. The results were by no means perfect, but there was a huge improvement in the children's views and we had seen this in their behaviour on the playground as well. However, there is more that we can do. We are working with local schools within an early years foundation group that we have set up to assist other settings to improve their DEI provision. As a school, we are moving towards the process of applying for and being accredited as a Unicef Rights Respecting School.

Action research project proposal: does including school community values in a digital technologies classroom impact understanding and perceived importance of these values?

Michelle: I was interested to see how the introduction of our school values would be understood by students, the importance of perceived use of the values, and how this might change with direct teaching and further immersion. The learning programme would be aimed at Year 9, where we had approximately 190 students, and take place from November 2021 to June 2022.

The action research would include questionnaires undertaken during Year 8, at the start of Year 9 and after project completion, measuring attitude and understanding toward the values of:

- Courage – mental or moral strength to persevere despite fear.
- Respect – showing due regard for the feelings, wishes and rights of others.
- Aspiration – a hope or ambition of achieving something meaningful.
- Compassion – to turn towards the suffering of others and respond with actions that show this same kindness, understanding, support and love as you would want to receive.
- Integrity – doing the right thing, even when no one is looking.

We would look for any changes in outcomes over the project to see if what we taught and offered had an impact on behaviours towards the school values. We would then make changes as necessary.

Plan/actions

The plan started with writing the questionnaire. In term 4 2021, via the home room or form tutor, all students were informed of the five school values. During this 30-minute lesson, students explored the values, identified gaps in these values in the school community, and designed a simple kindness project to address any identified gaps and grow more kindness in our community.

During the technology lesson following this, we asked all Year 8 students to fill in the questionnaire. Based on these results, the action we needed to take before we started to teach the cohort in Year 9 was to teach the students about personal values, specifically the school values, before we questioned them again. We increased lesson time to two lessons.

In term 1 2022, when the values were launched in the school diary, they were called "community values". During the two lessons, students explored what values are; they explored personal and cultural values and listed up to 10 values they found important in their lives. They then made a list of how they could put them into practice and identified SMART goals that were specific, measurable, achievable, realistic and timely. Students explored the community values and we used simple videos to explain each. Students wrote a list of how they could put each of these community values into practice over the group project that followed, and all Year 9s were then asked to complete the questionnaire. Reading the responses, respect had had a large jump in importance, but aspiration had fallen.

Based on these results, the action we took next was full immersion in our project across the senior school. In terms 1 and 2 2022, we had to adapt the programme to virtual delivery due to Covid-19. The values were our focus during assemblies, house meetings, year group meetings and home room activities. However, some of these activities were cancelled due to the pandemic.

After the showcase, a final lesson drew the girls back to community values. The students identified how they put the values into practice during the project and ideated on how they could improve for the next time they work in a team. All Year 9s were then asked to fill in the same questionnaire and the results follow.

Results

Q1 was an open-ended question: what is your understanding of the value?

Having reviewed all answers, the percentage of understanding was calculated. All values started fairly well. All improved, particularly so for aspiration.

Q2 used the net promoter score concept to gauge how important the value was to students on a scale of 0 to 10. If a student chooses 9 or 10, they are regarded as a promoter. Passive students respond with a 7 or 8. Detractors respond with a score of 0 to 6, showing they are unhappy with a value and may even discourage others from supporting it. Respect scored highly in all questionnaires. All values had risen by the second questionnaire and dropped by the third. The final results for integrity, aspiration and courage had dropped below the first questionnaire.

Q2 How important is 'VALUE' to you?

	RESPECT	COMPASSION	INTEGRITY	ASPIRATION	COURAGE
T4 2021	46	29	22	23	30
T1 2022	55	34	25	20	31
T2 2022	51	30	20	18	27

Q3 was a simple multi-choice question: how much of that value had the student shown in the previous 24 hours? An easy-to-recall amount of time, we felt.

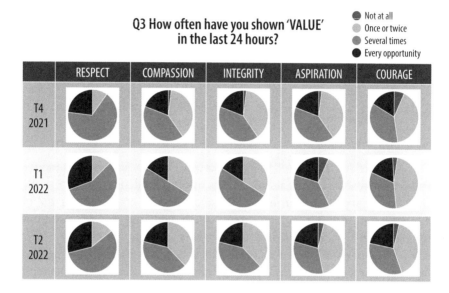

We were surprised to see "not at all" in any responses and we were particularly looking for a reduction in such responses over time. It was good to see that compassion and integrity had no "not at all" responses. Respect again came out as the value clearly supported by the students, and aspiration and courage the least.

Q4 was another simple multi-choice question: do they feel they have been shown the value at school in the last 24 hours?

Q4 Do you feel you have been shown 'VALUE' at school in the last 24 hours?

● Yes
◐ No

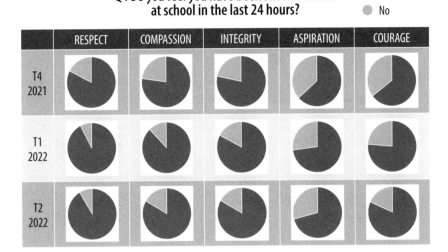

	RESPECT	COMPASSION	INTEGRITY	ASPIRATION	COURAGE
T4 2021					
T1 2022					
T2 2022					

Reflection

Understanding of all values sits at 98-100%. When it comes to importance of the values, why were aspiration and integrity so low in comparison with the others? Is it worth investigating why the more students understood aspiration, the less important it became? For the values shown *by* the students, aspiration and courage were the lowest – why? For the values shown *to* the students, aspiration was the clear low – does this connect to how important it is considered to be?

Within 24 hours of completing this programme, we ideated on how we could improve our approach for next year within the technologies department. This includes more explicit examples of the values, as well as in-house direct teaching of the whole programme. Important next steps are discussing these results with executives in order to aid the whole-school approach going forward.

Final reflection on the GMN project

Michelle: The project reinforced my strengths and team values from my Insights Discovery report, e.g. committed, creative, consistent, dependable, disciplined, precise high standards of myself and others. There were clear advantages to Jo and me pursuing two different action

research projects while supporting each other. I found the process involving and the outcomes of this project valuable on so many levels. The project was also rewarding as it enabled me to prove and challenge my areas of possible weakness. For example, being sensitive to Jo's feelings throughout, but particularly in the early discussions; being receptive to change when immersed in my own original idea and then adapting to it; and being more understanding with regard to other people's priorities, their own workplace demands and, of course, Covid.

Joanne: Being paired has been a really useful and valuable opportunity. It has meant there is someone to talk to when working through the problems of the research project, seeing what other people were experiencing and what was going on for Michelle at her end.

Teaching for belonging: a study into increased student engagement with the aim to increase mathematical confidence and competence

When I was paired with my partner, Marcisha Brazley-Keith from St Mary's School in Memphis, Tennessee, US, we decided to explore the work of diversity in our joint project. In our meetings, we decided to come up with one word that would encapsulate what we were trying to achieve in our spaces. After a few weeks of reflection, we came up with the word "belong". This was rather fortuitous, as the word was identified by my head of school at the end of 2021 as one of the four words that would capture our school's theme for 2022. The other words are "learn", "lead" and "serve".

My partner is head of the lower school at St Mary's and she had indicated that the place where she wanted to start bringing a sense of belonging to her school was in the library. She particularly wanted to explore creating a checklist that would help the librarians decide on books that were not only representative but told positive stories about minority groups. She had made good progress on this but unfortunately had to withdraw from our joint project.

When I first looked at the topic of belonging, I was looking at the area I am most passionate about and that is mathematics teaching. I have been in the maths class for over 12 years and have always enjoyed teaching Grade 8s. It is an opportunity to infuse a deep passion for maths that I hope will last their high school years and beyond. I find that Grade 8s have no inhibition and love to show off what they know from primary school.

My group of Grade 8s arrived in my class in January 2022 and, as usual, I did a pulse check of their goals for the year in the maths class. Many of their stories centred around their final year of primary school being spent behind screens and how, for most, the subject that suffered most was mathematics. Having done this activity for many years, I expect there to be some or other indication that perhaps the relationship with mathematics is not as it should be, but I was overwhelmed by the number of students who felt they had missed out on key concepts between Grade 6 and Grade 7 because they did not have the face-to-face engagement with their teacher or their peers. For context, our Grade 8 students write a baseline assessment at the start of each year and that assessment determines which class they end up in. The top sets are determined (top half of the grade of 100 students) and then the remaining half is split between three classes. I teach one of those three classes.

After my first lesson with the class, I felt that all those years of teaching had not prepared me for the shift in pedagogy I needed in order to teach the Grade 8s post-pandemic. I was just coming out of the shift needed to teach in a pandemic, but the aftermath was upon me and I felt deeply that my students needed to feel belonging again in order for them to do well in Grade 8 mathematics. Through my engagement with my mentor, she introduced me to the work of the education professor Rochelle Gutiérrez, which inspired me to further study the concept of teaching for belonging in the mathematics classroom.

Research focus

The idea of teaching for belonging was a very broad topic and I needed to narrow it down to one focus point. In the research I did around some of Gutiérrez's work, I noticed that she focused on dehumanising mathematics and creating access for minority groups. Although this would have been an ideal research topic for my class, I felt strongly that

I needed to address a more pressing issue around teaching post-Covid. I felt that the information I gathered in the baseline data around how much students value engagement in the class was a good springboard for me. I was also trying to find a topic that would have a greater impact on the group given their context. Based on the data and my personal passion for creating a student-centred mathematics classroom, I decided to focus on engagement (student voice) as the indicator for the term.

Baseline data

I gave the students a Google survey, example questions from which are shown below.

- Talk about a time you felt a sense of belonging in any classroom.
- What is one thing that helps you do well in mathematics?
- Name one thing you would like to see more of in class now that we are back on-site.

From the feedback, I was able to establish the following:

- Students felt the greatest sense of belonging when they were included in the lesson. They also mentioned that they feel a sense of belonging when they are called by name.
- They missed the human interaction around mathematics. The interaction was with their teachers and their peers.
- There was no clear indication that students ranked peer engagement below or above teacher engagement. It seemed to be that they saw the potential to learn from both. There were some outliers who preferred teacher engagement.
- The students made an association between spending time talking about maths (with a teacher or a peer) and doing well in maths. This came from their belief that if you can explain something then you must understand it well.
- The students wanted more fun mathematics activities such as Kahoots.

Tools
- Recording of student name.

- Student talking cards.
- Small groups.
- Class roles:
 - Timekeeper.
 - Assistant (handing out and collecting materials).
 - Summariser.
- Surveys.
- Looking for opportunities to make the content relatable.
- Varied assessment tools ("do nows", exit tickets, Kahoots, etc).

I created a document that contained links to video recordings of the students saying their name three times. I also asked the students to include any information that might be helpful in creating a classroom of belonging for them as they start their high school journey. I tried not to be too prescriptive and actually received varied responses from students that included their preferred pronouns, details around their family structures and who to contact, as well as other general information about their personalities. I gathered the data for all 100 Grade 8s and I do want all the students to feel a sense of belonging in all their classes. I shared this document with the staff.

I have always used talking cards – cards with student names that I use to cold-call students and also to ensure there is equal share of voice in the lessons – but this year I was intentional about using them not only for responses during homework review but also when deciding class roles, as well as for the weekly shoutouts. I gathered data from the students throughout the term to help guide the approach used to increase their engagement in class.

FEEDBACK: MRS NKOSI-MNANZANA

Please share openly and honestly about the experience in the Grade 8 Maths class. This will assist me to support you better and help me grow as a teacher.

In my explanations, I tried to relate the content students are doing in mathematics to a concept outside of the maths classroom. This helps the students and the elected summariser when we start class the next day.

I explain to students that a mathematical expression is the same as a sentence in English. In maths an expression is made up of terms, and in English it's made up of words. So words and terms are equal. The minute I found this cross-curricular link between the subjects, the students felt a deep sense of relatibility.

TC Nkosi-Mnanzana ⋮
May 4

Dear Grade 8s

In today's lesson we looked at the basic definition of algebra, which is a branch of Mathematics that uses both numbers and letters (or variables). We spoke about variables being any letter that represents a number. We also spoke about the difference between sentences in English and expressions in Mathematics. Where English uses words to make up sentences, in Maths we use terms to make up expressions. In English, words are separated by spaces but in Maths, terms are separated by a + or a − sign. We looked the definitions of the words monomial, binomial, trinomial and polynomial. We ended the lesson exploring what are like and unlike terms.

At the start of the project, only 10% of students felt belonging in the maths classroom. By the end, that number had leapt to 70%. They had better recall of the work they were doing in maths; they were more confident and needed less prompting. There was a lot of reframing of the language we used – it was a struggle but a productive struggle, which is a good thing.

I love mathematics and I love teaching mathematics. I hope that in building this belonging checklist for my students, they can get an appreciation of it as well!

Mind the gap: a teacher's-eye view of ethnicity and socioeconomic status in UK schools

ERIN SKELTON

When I set out in September 2021 to undertake a piece of educational research that focused on independent girls' schools in the UK, I wanted to focus on diversity, equity and inclusion. The momentum gained between the Everyone's Invited and Black Lives Matter movements in 2020 has been a force for great change in girls' education globally. I had initially planned to look at the impact of race, ethnicity and inequality in single-sex educational settings. Working within a trust of girls' schools gives a unique insight into the impact of single-sex versus co-educational learning environments and, when intersectioned with racial and socioeconomic inequalities, this again changes.

The second focus of my research, and perhaps also of my teaching career, is the relationship between individualism and collectivism in education and educational policy. I trained and worked for a decade in state education, where the drumbeat is very much one of closing the gap between expected and actual progress of groups of students. Pupil tracking is undertaken on the basis of cohorts and students are identified by gender, academic ability, learning need, ethnicity and whether they are in receipt of free school meals (FSM). Data, widely published by the

Department for Education (DfE) and bodies like the Commission on Race and Ethnic Disparities (CRED), is used to form the basis of Ofsted inspections and shapes the narrative of underachievement in state education in the UK.

When analysing the achievement and attainment of students nationally by modelling cohorts, children are collectively categorised and their data is compared: their ability levels against standardised testing and their progress at key points of their academic journey against a national benchmark. This process, in itself, is a form of social categorising and can lead to unconscious and conscious bias in our systems of education.

When analysing the achievement and attainment of students nationally, classifications of ethnicity from the 2011 census in England are used. Again, the use of these classifications often fails to support individualism in education and many sociologists, such as Peter J Aspinall, now question the use of classification on a range of levels (Aspinall, 2022).

Nationally, the cohorts of students with lowest achievement against progress measures are traditionally students from White British, Black Caribbean, and Mixed White and Black Caribbean backgrounds from low socioeconomic status contexts. Additionally, the data shows a larger rate of underachievement for boys than girls. Furthermore, boys from low socioeconomic status contexts from Pakistani, White Other and Any Other ethnic groups also score below the mean scores for achievement nationally.

Educationalists and government organisations like the CRED hypothesise many reasons for this underachievement, ranging from theories of "immigrant optimism" (Kao and Thompson, 2003), "segmented assimilation" (Portes and Zhou, 1993), teacher expectations led by unconscious bias and "cultural norms" (Strand, 2021). And yet, when you also look at the underachievement of students from White British backgrounds with low socioeconomic status, the question also becomes one of how low socioeconomic status could be the key factor in the underachievement of students in UK schools.

The 2020 report published by the Runnymede Trust entitled *Race and Racism in English Secondary Schools* focuses on the disadvantage that exists in UK schools as a result of racial inequality. From this report I

could see obvious patterns that fit with the statistics from the DfE and the CRED: a lack of representation, overzealous policing in inner-city schools, a curriculum that does not address the diversity of society nor the colonial legacies within modern Britain, school policies that don't embed a culture of anti-racism, as well as links between racial inequality and low socioeconomic status, a lack of access and opportunities, and how a geographical area fits into POLAR and TUNDRA classifications for widening participation. I could evidence this from my experiences in state education and yet this was in no way the evident pattern in my current educational setting.

I have observed, since taking up my current post in 2017, that independently educated girls in single-sex day schools from Black African, Black Caribbean, Mixed White and Black Caribbean backgrounds, particularly those who gained assisted places, have often underachieved against their expected progress according to their data profile: a combination of SATs, MiDYIS and ALIS testing alongside actual GCSE and A-level results through terminal examinations. Their GCSE results were often not in line with predicted flightpaths based upon prior attainment and this underachievement often carried through from GCSE to A-level. Girls on assisted places from White British and Any Other backgrounds in non boarding settings had similar outcomes. Additionally, students from these groups often left Year 13 with an "added value" measure that was below zero – wholly unexpected in independent schools. And yet, looking back to the Runnymede Trust findings, there isn't an easily evidenced pattern to explain this. These students have access, opportunity and an outstanding educational and pastoral provision. The most obvious pattern is low socioeconomic status and whether the student lives in a POLAR/TUNDRA classification for widening participation. Again, this drew me to question the importance of low socioeconomic status as a factor in underachievement.

At this point, I was fortunate enough to work with our lead on diversity, equity and inclusion. At the time of my research, she was leading strategies to open dialogue around the lived experiences of students that originated in the dialogue surrounding the Black Lives Matter movement. The conversations centred around historic bias, both covert and overt, and the long-term impact on individual students and wider cohorts.

Listening to these personal accounts, I noted that there was a significant difference in lived educational experiences of different communities of students and often an acute awareness of the differing levels of privilege evident socially between the students. Although the initial dialogue was around ethnicity and White privilege, it became increasingly apparent that there is an issue surrounding socioeconomic privilege and often the two are intertwined in an independent educational setting.

Here, I decided that I needed to draw on my previous teaching experience and compare and contrast educational settings.

The first of my schools was a state Catholic school in a deprived area of north Nottinghamshire that held approximately 1000 students. The demographic in the school was overwhelmingly White British, low socioeconomic status and predominantly Christian or those identifying as having no religion. Between 2007 and 2013, around 5% of students were Black Caribbean or Mixed White and Black Caribbean; 3% of students were from an Asian British background. For these students there was little, if any, positive acknowledgement of ethnicity and an approach of racial colour-blindness was often adopted by staff and students. This differed from the experiences of students in the school who were from Any Other ethnic backgrounds, predominantly students from Greek or Cypriot backgrounds. This group of students did not have the same experiences of being made to feel invisible or othered. In terms of achievement among these groups of students, underachievement appeared to be a combination of teacher expectations, poor representation and low socioeconomic status, as there was no definitive pattern that could be applied to each student relating to ethnicity; however, a larger cohort of students could change these findings. Students from White British backgrounds from Traveller communities experienced underachievement as a result of teacher expectations, cultural norms around girls' education, gaps in provision when travelling and struggling with a structured learning environment. Often, these students arrived in secondary education below the expected progress measures for an 11-year-old and the gaps in learning were too vast to be closed by GCSE. Students from Any Other White backgrounds whose families were economic migrants from Eastern Europe and who were learning English experienced the most prevalent bias and discrimination – both

unconscious bias and overt discrimination from their peers. However, these students broadly achieved in line with their expected progress or overachieved against their flightpaths. Despite low socioeconomic status and speaking English as an additional language (EAL), parental input and teacher expectations for these students were high.

By 2013, I had been a head of department in this school for six years. In that time the school had gone from an Ofsted rating of "good" to "inadequate" and back to "good with outstanding features". We had three headteachers in five years, a school building built in 1974 that struggled with our numbers and our needs, and we were required to rigidly adhere to a strict inspection framework at all times. National measures mattered the most and the lived experiences of the students were often lost in that process.

In 2013, I moved to a large state Catholic school in inner-city Sheffield that held approximately 1200 students. This was a divergently different school to my previous one in that it was more ethnically and religiously diverse. Around 19% of the students were from Black African and Asian backgrounds from Eritrea, Nigeria, Yemen and Bangladesh. This was in addition to a large community of Any Other White students from Eastern Europe and a further group of White British students from a range of Traveller communities. Here, I would argue that the findings of the 2020 report by the Runnymede Trust were most evident. There was a significant gap between predicted and actual progress, in addition to a definitive link between sanctioning behaviour and ethnicity. By this point in my career, I had been a head of department, head of year and strategic subject leader. What often struck me in my pastoral and academic interactions with the students was that they existed in an educational environment where they had to fit, not one that was built around them. Their intersection often remained unseen other than to ensure that their progress was maximised. The nuances of EAL, the cultural implications of FSM eligibility, access to engaging and relatable curriculum content and inspiring representation were never strategically looked at in any meaningful way. And yet, the constant questions were about ensuring excellent behaviour, improved outcomes and meeting national measures.

In 2017, I moved to my current setting, a selective, independent girls' school with a trust-wide strategy of fearlessness, civil discourse and making sustainable sociopolitical change. 58% of students are from White British or Other White backgrounds, 28% of students are from Asian backgrounds, 7% are from Mixed backgrounds, while around 2% and 5% of students respectively are from Black backgrounds or Any Other ethnic backgrounds.

Comparing the three schools I have worked in across the 15 years of my career, I didn't find a definitive pattern. However, I found a complex intersection between bias, both unconscious and overt, the impact of low socioeconomic status, parental input and teacher expectations, held up by the system used to track progress nationally.

The connection between socioeconomic status and underachievement in independent schools is not particularly obvious. At this point, I decided to do some further qualitative research and focused on the lived experiences of alumnae who had attended on an assisted place. Many of these women outlined having an increasing awareness of the privilege of others as they moved through school; of feeling "different" in social settings, which then affected their sense of belonging. In some cases, alumnae outlined feeling that teachers had lower expectations of them; they could outline situations where they had not undertaken something to the standard they were capable of, and their surprise when no concern was raised by their teacher regarding this. Some outlined measurable gaps: a lack of private tutors, access to resources, trips that would give them better opportunities, etc. Some alumnae spoke about a sense of gratitude had by their families, and subsequently a sense of not wishing to be seen as ungrateful if they ever felt they needed to make a request for additional support. Some spoke about their wider contexts, a lack of awareness of the true nature of their EAL, or the context of their homes not being as conducive as possible for the level of independent study required for them to gain top grades. Some spoke about their parents not being able to support at home with homework or university applications because they were working or lacked the experience to help. In many of these situations, it became apparent that a lack of understanding of economic and cultural context was a part of the wider issue and that there was a lack of equity in many of these scenarios that went unseen.

In order to begin to address these issues, we continue to give alumnae, students and staff the opportunity to enter into a dialogue about their lived experiences in their education. This has led to staff training on micro-aggressions, unconscious bias and racism, and will lead to further training to support the staff in supporting the students. We appointed diversity prefects for the 2020-21 academic year and their role now focuses on ensuring that students have a voice and an active say in the strategy surrounding diversity, equity and inclusion. For the 2022-23 academic year, our sixth form PSHCE curriculum will also include socioeconomic privilege and classism; training and assemblies will better address a gap in understanding that students have. As a staff body, we are working to diversify our curriculum and look to a wider range of resources that represent our student body.

In order to ensure that our existing community feels supported and included, we are working towards building a programme of advocacy within the school. This will build upon the comments of the alumnae and students, and will be both pastoral and academic. We are beginning to trial a mentoring programme that will be undertaken by staff, students and alumnae, and will look to extend this to some of our governors. This could include careers mentoring, pastoral support or proactive academic mentoring. We are also raising awareness among the staff of which of our students are on assisted places, what their data indicates they should be aiming for and what some of the challenges are that they need support to overcome; this could include what their EAL status indicates in real terms, whether they are carers at home and how much support is available to them outside of school.

To attempt to address a lack of access and opportunity, the mantra within the sixth form is very much one of using your connections and your privilege to raise up other girls and women while you are a student and when you become an alumna. We are using this mantra to springboard a package of support across our local area. This will include partnership work via our volunteering and charitable strands, and we will work with some of our local charitable partners to support their efforts in the local community addressing issues that directly affect women and children. At school level, this will also include us working with our local state schools to provide careers guidance, university preparation and support

for applicants applying for competitive university courses or Oxbridge. We have committed to inviting our local state schools to our lecture series events and careers evenings, and are planning to host our local universities in providing widening participation opportunities in the next academic year. We are now actively seeking applications for assisted places from students in our local state schools and are supporting them through the application process. This has enabled us to support one of our local state schools in setting up their own network of alumnae who wish to give back to their community.

Our outreach and partnerships coordinator will be implementing a new strategy in the autumn that will involve us working with one local state primary school in a POLAR/TUNDRA classification area. This will result in an ongoing partnership with this school that will feed into our assisted places, and later into a mentoring programme where students in KS3 and KS4 will mentor students in the local primary school and then other students as they move up the school.

The relationship between socioeconomic context and educational inequality is vast and could be spoken about in terms of educational outcomes, standards, adding value or closing gaps, but progress against targets seems to be the only quantifiable measure that is nationally recognised. Underachieved grades on results day are only a small part of a much wider issue, one that permeates many aspects of identity and education and has a continuous impact upon future generations. Through grassroots strategies, mentoring and partnerships between independent and state schools, we have the power to begin to address the long-term impact of a student's socioeconomic status on their educational outcomes and ensure that they fulfil their aspirations while giving back to the next generation.

Bibliography

Aspinall, PJ. (2022) "Do conceptualisations of 'mixed race', 'interracial unions', and race's 'centrality to understandings of racism' challenge the UK's official categorisation by ethnic group?", *Genealogy*, 6(52)

Joseph-Salisbury, R. (2020) *Race and Racism in English Secondary Schools*, Runnymede Trust, www.runnymedetrust.org/publications/race-and-racism-in-secondary-schools

Kao, G and Thompson, JS. (2003) "Racial and ethnic stratification in educational achievement and attainment", *Annual Review of Sociology*, 29, 417-442

Office for Students. (2021) "About the TUNDRA area-based measures data", www.officeforstudents.org.uk/data-and-analysis/young-participation-by-area/about-tundra

Portes, A and Zhou, M. (1993) "The new second generation: segmented assimilation and its variants", *The Annals of the American Academy of Political and Social Science*, 530(1), 74-96

Strand, S. (2021) *Ethnic, Socio-economic and Sex Inequalities in Educational Achievement at Age 16: an analysis of the Second Longitudinal Study of Young People in England (LSYPE2)*. Report for the Commission on Race and Ethnic Disparities (CRED), Department of Education, University of Oxford, www.education.ox.ac.uk/wp-content/uploads/2021/05/Strand_2021_Report-to-CRED.pdf

Professional
development

Coaching: getting started

STEPHANIE WALTON

Context

Melbourne Girls Grammar is an Anglican girls' school in Australia, with girls from age 3 to Year 12. We were established in 1893. Our values are:

- Integrity.
- Compassion.
- Courage.
- Self-discipline.

In 2019, the year I started, we also had a new principal, Toni Meath. Shortly after she became principal, we introduced a new strategic plan. In the plan we highlighted the need to:

- Strengthen a performance and development culture that is inclusive of students and staff.
- Become an employer of choice and to encourage staff growth and retention.

We have not previously utilised coaching and there were some challenges that I envisaged. There was some reluctance from staff to participate: people were talking about professional growth but were apprehensive that coaching was some sort of performance management. Would it impact their ability to have a job, or stay in the job?

One of the key principles of our coaching framework is that it is voluntary. There was a big discussion in the team about how appropriate it would be to make it mandatory for staff, but we felt that would go against the principles of coaching. Fundamentally it was about staff being the best they could be.

Background research

I visited the Bishop Strachan School in Toronto, Canada, as part of a student and teacher exchange and saw the work of Jim Knight, the author of *Better Conversations* (2015). That became our text for the year. I completed a course: Introduction to Leadership Coaching.

I coached my first colleague at the end of 2021. The notion of *Better Conversations* informed more formal and better organised coaching sessions. It has also influenced and dripped down into my day-to-day conversations. This has enabled me to take more of a coaching stance in my everyday life in school. It has emphasised the continual nature of learning and it has allowed me to adopt some new habits and get rid of some old ones!

When I was starting my journey in coaching, and through the Global Mentoring Network for Aspiring Leaders, I improved my ability to listen with empathy. I am still working on and trying to limit my interruptions. I am trying to ask better questions. I am becoming better at redirecting conversations when they have gone down a negative route.

It has worked really well doing this alongside the mentoring I received. I know mentoring and coaching are different, but I have taken some of the ideas for mentoring and used them in coaching. One of the things I worked on quite hard with my mentor was not beginning with an apology, which is something I often did. I have also tried really hard to apply the belief that the conversations we have as part of coaching should be life-giving, energising and enjoyable – something that my conversations with my mentor were.

The results

We employed two instructional coaches for the school, one in primary and one in secondary. In all, 30 staff completed Introduction to Leadership Coaching.

In term 1, we advertised and sought expressions of interest from people who wanted to be coached. In term 2, I started coaching two staff members.

Case study 1

The idea of being outside the classroom stemmed from the notion that conversation should be life-giving: engaging, building energy and feeling better. It gave us greater freedom of expression than we would have had in an office. It also removed a lot of the physical barriers between us: table, etc. I coached someone I had a relationship with, that I had some trust with, rather than building it up from scratch.

We did an exercise I had done with my mentor, which asked you to look at your CV and identify 10 accomplishments. My coachee had the same reaction I had experienced – "I haven't got 10 things" – but with some encouragement she got there. We also did some practice interview questions and worked on her personal strategy. She looked at her professional life but also how that connected with what she wanted to do in her personal life.

We used the GROWTH framework:

- Goals.
- Reality.
- Options.
- Will.
- Tactics: how and when will you do it?
- Habits: how will you sustain your success?

I found this was a nice way for me to introduce myself to coaching – it wasn't confrontational, it wasn't scary, and it allowed me to have a lot of reflection on what it is like to be coaching and what it feels like to be a coach. It meant that when I made many mistakes, which I feel like I did at the time, I wasn't frightened to look down at my notes or check with them later.

The person I was coaching has taken two new leadership positions within the school – she has taken on two really challenging roles. It's been a really beneficial process for both of us.

Case study 2

We used principles from Jim Knight's book *The Impact Cycle* (2017). This was more about practice in the classroom, rather than about career aspirations and goals. What we did was that each of our students completed pivot surveys about their teachers. You then get given three things that you're really good at and excelling at, and three things that might need some enhancement. They are all linked to our teaching standards in Australia. Coachees also have to observe their own teaching, or be observed teaching, and they can then pick, in the spirit of coaching, what they would like to focus on.

There was some resistance here, as some staff felt it was like being performance-managed. I was uncertain what to do – I couldn't tell them what to do. I realised we had some swivels (remote-controlled movable tripods for cameras) left over from remote learning. So I said, "How about we use the swivels?" and I set those up for them. That was the point where the coaching went from something that I planned and was working towards and wasn't really happening to ramping up quite quickly. As you're teaching, the swivel follows you around the room. It allowed the teachers to get a good oversight of what they were doing in the classroom. It allowed me to be in the classroom with the coachees.

As a result, coachees have become self-directed in their coaching. They identify what they are going to work on now they have a clear reality of what's going on in their classrooms. We will have conversations about what they think they will do to enhance their teaching. One of the people I was coaching was speaking at a million miles an hour; she was also spending a lot of time giving out instruction and leaving very little time for the students to practise, consolidate. She noticed that herself through watching. She also noticed things about her voice inflection: she got very high-pitched and very excited. She has worked on her use of voice in the classroom. She has worked on use of learning intentions and success criteria.

As part of that, we will do a bit of research together. I might direct coachees to some other teachers. My hope is that these teachers will become coaches in the next round.

Feedback

"I really enjoyed this type of coaching and being more self-directed, as I feel I have a greater sense of control, motivation and excitement. I feel less of a sense of having to try and impress someone – it's more about how to challenge and improve my teaching. Being able to record my classes in my own time, and then review them, I can see as being a great way to take the pressure off feeling like I had to perform, and I can do so at my own pace. I liked the way you asked questions that I would not necessarily have considered and felt encouraged when I was feeling self-critical."

Overall, it was a really positive experience. My learning partner in England was approaching it in a different way, looking more at coaching of students. That is something I would like to do more of at Melbourne Girls Grammar.

The forgotten middle: developing an in-house professional development programme for middle leaders

ALEXANDRA GREENFIELD AND KAREN WHELAN

Rationale, methodology and outcomes

One of the reasons we decided to focus our work on middle leaders was that we knew they were an incredibly important part of any school and that the landscape was changing quickly in terms of leadership. We felt this area of our leadership had been ignored somewhat in the past. A lot of research shows that great leadership is needed – this was mirrored in the feedback we received from our individual schools. Therefore, we thought this was an area of potential interest for both of us.

Middle leaders are pivotal in the leadership structure. They are at the interface of many different areas of school leadership yet they are often forgotten in terms of leadership development. What Karen wanted to look at was:

- How middle leaders could grow professionally.
- Building capacity within her school so middle leaders could deliver their role effectively.
- How effective middle leadership impacted student outcomes.

In addition, Alex was aware that her senior management team were keen to develop a curriculum for middle leaders.

Each of us undertook a literature review from our respective contexts – Karen in Australia and Alex in the UK.

Overview of literature (Australia)

- Middle leadership is incredibly hard to define. It's difficult to figure out who the middle leaders are in a school. To come up with a global definition is also difficult.

- It's hard to define the responsibilities that middle leaders hold, because they vary so much within different schools.

- Research by Paul Craig Wattam (2021) explores the opportunities and changes that schools could make in terms of the development of middle leaders. He makes a series of recommendations that senior leaders and policymakers could choose from when considering their contextual priorities. Wattam's recommendations include:

 ◦ "Improve opportunities for professional development and learning."

 ◦ "Implement an aspiring middle level leader program."

 ◦ "Identify support structures for middle level leaders."

 ◦ "Strengthen connections between middle level leaders and senior leaders."

Overview of literature (UK)

- Any programme for middle leaders has to be specific to the context of those middle leaders – there needs to be some evidence of an individual approach. Middle leaders have a very wide range of experience.

- The challenge lies in how to create a programme that caters for someone who is new in post – even less than a year in some cases – as well as those who have been in post for up to 10 years and beyond.

- Any effective CPD has to be differentiated for the people who will receive it. We had to be aware of that and worked very hard with our teams to ensure the programme we developed was relevant and meaningful to them.
- Improving school leadership is the best way to make sure every pupil gets a great education. According to Melanie Renowden, former interim CEO of Ambition Institute, "No other aspects of the school system have as much influence on pupil achievement" (Ambition Institute, 2019).
- An effective CPD programme for middle leaders must recognise the value of domain-specific knowledge, allowing for the "filtering" of generic leadership skills into a more contextualised programme.
- A CPD programme that meaningfully develops staff must take into account the leaders' existing expertise and focus on helping them to improve relative to this. In a review of effective professional development programmes, the Teacher Development Trust (2015) identified "the importance of programmes that provide differentiation: opportunities for recognising the differences between individual teachers and their starting points."
- The Department for Education has recently removed its National Professional Qualification for Middle Leadership, replacing it with three National Professional Qualifications that focus on developing leadership in three specialist areas, reflecting the understanding that middle leaders may lead in a range of areas and therefore a specialised approach is required in terms of training and development.

We decided that, based on the research, we wanted to develop a bespoke in-house programme for middle leaders that:

- Built on the capacity of the school's middle leadership team.
- Catered to the specific and most immediate needs of middle leaders.
- Was largely delivered by a variety of in-house experts (allowing staff to build their own presentation skills), with the involvement of the occasional outside expert.

- Had the capacity to change and adapt on an annual basis, based on the middle leaders' area of development, current research on leadership and the in-house areas of expertise.
- Was cost-effective.

When you create anything that is bespoke, it has to be contextual and must be developed from the ground up.

Defining middle leaders

We defined a middle leader as:

"A middle leader holds a pivotal role in a schools' organisation, as they are positioned between the senior leaders and the teaching staff and have both formal leadership and teaching responsibilities."

St Albans High School for Girls (Alex's school) focused on the curriculum for academic middle leaders only, whereas Shelford Girls' Grammar (Karen's school) looked at both academic and pastoral leaders.

Methodology

1. Engage stakeholders, which for us was two key groups: our senior management/executive teams and our middle leaders. We realised we would need buy-in from both sides.
2. Data and information gathering at senior management and executive level.
3. Management of people and teams – they are distinct skills.

Analysing the data: Shelford Girls' Grammar

For inexperienced and experienced middle leaders, the top two subjects were:

1. Effective communication (including handling difficult conversations).
2. Working with senior management/managing up.

Preferred styles of delivery were a mix of different modes. Key words from responses were:

- Engaging.

- Reflective.
- Provide ongoing support.
- Give an opportunity for discussion.
- Build capacity.
- Have clear and tangible takeaway strategies.

Analysing the data: St Albans High School for Girls

Managing staff performance development and quality assurance processes proved to be the two areas where middle leaders said they most wanted support. This reflects the step up from classroom teacher to middle leader: as a middle leader, many are more confident in teaching and learning and curriculum design. When you move up to a middle leadership position you are suddenly faced with managing people, which is very different from what you've had to do before.

From more experienced middle leaders there was a broader range of needs. Some were very confident at managing people but were more interested in curriculum design and development, leading for change and, to a lesser extent, working with senior management. This highlighted the difficulty of designing a programme that would work for such a variety of people.

One thing that emerged from the data for both of us was that a lot of middle leaders wanted time, particularly time to reflect – not a one-off session but something delivered over the course of a term. This reinforced what the research was saying.

The dream for any school is to build professional learning time within the school day. What surprised us was that we thought we would run a programme that would involve a session on one topic, a session on another topic and so on. What the research told us was that middle leaders wanted time to dig deep and go slow. That changed our trajectory – we knew we wanted to pilot something – and what we ended up doing was quite different.

Evaluation: Shelford Girls' Grammar

- Successful rollout of **Difficult Conversations** PL programme during term 2.
- The early stakeholder feedback gathered was invaluable in regard to the design of the program. It guided:
 - Content.
 - Pace.
 - Length of sessions.
 - Style of sessions.
- Running a topic per term will enable us to tailor the programme even more in the future and allow our MLs to self-select depending on their need and experience.
- It has built camaraderie among our ML team.
- Combining wellbeing and curriculum leaders enabled us to develop common ground and shared outcomes.
- We will seek feedback at the end of this first course that will help to inform the creation of our next programme: **Managing Up, Down & Sideways**.

Evaluation: St Albans High School for Girls (STAHS)

Due to previously timetabled CPD events, Alex was unable to run the pilot programme.

However, Alex was able to run a standalone session on using lesson observations as part of the accountability process during a HoDs meeting in November 2021. This enabled her to plan a further sequence of sessions that followed the principles made apparent through the survey data.

Alex is now working with her current head of CPD to develop further training for middle leaders as appropriate.

Overview of research/existing literature (AUS)

- Lipscombe, Tindall-Ford & Lamanna (2021) concluded that:
 - Middle leadership is difficult to define.
 - The responsibilities they hold vary considerably and are best understood in context.
- Wattam's (2021) research on the role of middle leaders in New South Wales (Australia) Catholic secondary schools further supports this.

- Wattam (2021) suggested seven recommendations that senior leaders and policymakers could choose from when considering their contextual priorities.
- Numerous of these recommendations are closely related to the development of leadership skills:
 - Improve opportunities for professional development and learning.
 - Implement an aspiring middle level leader programme.
 - Identify support structures for middle leaders.
 - Strengthen connections between middle and senior leaders.

Overview of programmes

Shelford – Difficult Conversations

	Timeline – Term 2
Week 1	Seek expressions of interest from MLs to take part in the first leadership topic – Difficult Conversations.
Session 1	What are difficult conversations?
Session 2	Preparing for the difficult conversation.
Session 3	Engaging in the difficult conversation.
Session 4	Follow up with specific actions.

STAHS – Performance Management and Quality Assurance/Accountability

	Timeline – Term 2
Week 1	Seek expressions of interest from MLs to take part in and/or lead the first leadership topic – Performance Management and Quality Assurance/ Accountability.
Session 1	What do we mean by performance management and quality assurance/ accountability, and what is a middle leader's role in this?
Session 2	Strategies and processes for effective performance management and quality assurance.
Session 3	Preparing to begin the performance management and quality assurance cycle.
Session 4	Review of performance management and quality assurance cycle, identifying further training needs if required.

Conclusions

Accomplished our vision in regard to:

- Bespoke – caters to current needs/all participants of similar level in regard to development of skill.
- Building capacity of MLs.
- Delivered by in-house experts.
- Adaptive.
- Cost-effective

Unexpected outcomes:

- Development of camaraderie and how quickly staff were able to feel comfortable in sharing experiences.
- Not as many curriculum leaders signed up as expected, despite numerous having previously set their individual goal to become better at having difficult conversations and acknowledging this was an area for future growth.

Future challenges:

- Engaging external experts who are able to work within our specific confines and who can offer cost-effective delivery.

A key takeaway is that there is so much expertise within your own school.

We had some unexpected outcomes. We found strong camaraderie and were pleased at how quickly staff were able to feel comfortable in shared experiences.

Not as many curriculum leaders signed up as expected – at Shelford, it's mostly been our wellbeing team that have come forward. Many of our curriculum leaders talked at the start of the year about how they wanted to improve their ability to have a difficult conversation, yet they didn't sign up. We couldn't have been any more clear on the topic: maybe it was the idea of it being a pilot programme that discouraged greater involvement.

Future challenges include engaging external facilitators who can work within our specific confines and offer cost-effective delivery. As part of this, we will need to ascertain how willing they are to adapt a pre-existing programme to suit us.

Recommendations

In developing an in-house bespoke model, context is the most important element. Who are your leaders and what is their experience? We wanted to create something that could be used within our schools but also adapted to other schools. It's crucial to link any development programme to the school's strategic plan, but the basic principles of our programme could be taken and used in any school. First, determine who the key stakeholders are and engage with them early and often. Then, run a pilot and invite middle leaders to attend – the word will spread. Seek feedback often and take it on board. Last but not least, ensure the programme evolves to meet changing needs.

Bibliography

Ambition Institute. (2019) "Ambition Institute is launched to help educators keep getting better", www.ambition.org.uk/news/ambition-institute-launched

Barker, J and Rees, T. (2019) "Generic and domain-specific perspectives of school leadership", Ambition Institute, www.ambition.org.uk/blog/generic-and-domain-specific-perspectives-school-leadership

Lipscombe, K, Tindall-Ford, S and Lamanna, J. (2021) "School middle leadership: a systematic review", *Educational Management Administration & Leadership*

Teacher Development Trust. (2015) *Developing Great Teaching*, https://tdtrust.org/wp-content/uploads/2015/10/DGT-Summary.pdf

Wattam, PC. (2021) "Understanding the role of the middle level leader in New South Wales Catholic secondary schools", *Leading and Managing*, 27(2)

Shapeshifting in a pandemic

RACHEL HART

"What is an integrative coach?" asked Amanda Poyner, my line manager and pastoral deputy head at the school I had rather miraculously landed in a year previously, still wearing the metaphorical parachute I had strapped to myself when I realised my future did not lie at the school I had spent well over a decade teaching in, in a variety of middle-management roles. Barely two terms in, my new school still felt like the career and educational equivalent of the land of milk and honey. "Well, I'm not exactly sure," I said. "I'll have to ask her that in our first meeting." Little did I know that this first meeting would also be the first step on a journey I had actually begun some time before, and that the integrative element of the process I was about to embark on would empower me to realise that the various roles I had held inside and outside the classroom could co-exist in relative harmony – provided the shared values were in alignment.

These conversations and meetings were also taking place through a medium and in a format we were hastily scrambling to adjust to, and which – rather than being the temporary measure we had set up just to see us through the next few weeks, after which point we thought we would be able to return to normality – would instead become the new norm. It was Easter 2020. I was head of PSHE at Lady Eleanor Holles (LEH) in London, UK, a role I had applied for while completing a postgraduate qualification in child, adolescent and family mental health and wellbeing at the Tavistock clinic in London. My years teaching in highly selective girls' day and boarding schools had revealed an

increasing need for professionals working in this space to be aware of and attuned to the therapeutic nature of their role, and – as a mother of four daughters myself – I already sensed the shifting tide that would soon become a tsunami of mental health crises. This specialist training had been the metaphorical parachute I referred to earlier, and I grabbed the offer of the PSHE role with both hands, brimming with ideas and good intentions to bring about positive change.

An effective PSHE curriculum does many things. It reflects the often idiosyncratic nature of the school in question, and operates within the culture of that environment to meet the ever-changing needs of its pupils, equipping them with the self-knowledge and skillset they need to navigate the increasingly emotionally (and practically, which is an added dimension for minority students, and I include female and trans young people in that category) complex landscape they will launch themselves into beyond school – or be unceremoniously launched into, as was the case for the Class of 2020. And, to do this successfully, the PSHE curriculum requires the buy-in of the whole school community, from colleagues delivering content to specialist providers reaching places many of us are neither trained or equipped to go, a supportive senior management team and an engaged parent body who will continue these sometimes-difficult-but-oh-so-important conversations at home. And the essential ingredient: pupils who feel that their voices are being heard while the programme is initially developed and then constantly revised.

There really should be an ITT (initial teacher training) route into PSHE, as it underpins the ethos of the school and is wholly cross-curricular in nature. It is not necessarily a straightforward role to step into in a new school. It was while I was processing this that the pandemic hit and my embryonic plans had to be rapidly adjusted, as PSHE became about responding to world events and their profound impact on the day-to-day lives of our impressionable, sensitive and sometimes vulnerable pupils. The isolation of Covid-19, the Black Lives Matter response to the horrific death of George Floyd, the increased use of social media platforms to bring about necessary and vital change following the testimonies of Everyone's Invited – it was becoming unavoidably clear that nothing would ever be the same again and that schools had become the conduit, the vessel, for change. Suddenly my role had a reach I had not initially

anticipated, and it was in the midst of this maelstrom that I received an email from the deputy head, Lindsey Hughes, asking if any heads of department would be interested in taking part in the Global Mentoring Network for Aspiring Leaders (GMN).

Emboldened by the realisation that I could perhaps make a real difference, and facilitated by the space that lockdown had created, I hastily updated my CV and asked if I could be considered as a candidate. It is so appropriate that the Girls' Day School Trust podcast is called *Raise Her Up*, as that is surely what we are trying to do in girls' schools for our pupils and our colleagues, and I am hugely grateful that my headmistress, the inimitable Heather Hanbury, supported my application. A phone call with Ian Wigston, once I had completed the Insights Discovery evaluation questionnaire, revealed my results (apparently, I am a Supporting Helper/Inspiring Helper) and allowed me to properly reflect on my career path while considering my inner motivations. I found this a fascinating exercise. According to my Insights report, I seek roles where my values can be fulfilled, and this conversation marked the start of my conscious journey of alignment and integration. Ian pointed out that I had been on this path all along and paired me with Suzanne White, my mentor, who told me in our first meeting that an integrative coach is one who enables the client to celebrate and integrate all areas of their life into their professional persona.

Working with Suzanne gave me the confidence I – like so many other women – had lacked for so long to see myself as my own brand (which, of course, is another vital lesson to teach our pupils and daughters). I began to put my experience, contacts and vision to good use, and to recognize the elements in myself that, without realising, I had already begun to hone in the shape of the female leaders I have most admired during my working life. Suzanne asked me, through a series of carefully selected questions, to create possibilities for myself and to walk through with her the steps it would take for them to become a reality. Suddenly, excitingly, everything seemed possible and – importantly for me – in a non-self-promoting or self-congratulatory way. Instead, I inhabited the quiet self-belief necessary to continue to build on the work I had already started at LEH, and in doing so to recognise and meet the changing needs of colleagues, pupils and parents, as we all collectively

learned to manage the enormous life-shift that the pandemic had brought about.

I let my creative streak run wild. I devised a sequence of sixth-form PSHE lessons based on the TV show *Normal People*, which had so captured the zeitgeist of its lockdown audience and which, for me, provided a perfect vehicle for talking about real issues facing our young people. These included accessing mental health services at university, which of course became a reality for the Class of 2020 when they found themselves stranded far away from the structure and scaffolding of school and home, unable to leave their student accommodation. In a similar vein, Ian suggested that the community project element of the programme should have a flavour of the situation we were all living through, and so we decided to look at the transition stages of school life, which are so often trigger points requiring most mental health support: Year 6 to Year 7, GCSE choices and, of course, A level to university. Over Zoom calls, Elizabeth Cross, Tracy Jean-Baptiste (fellow participants in the GMN) and I discussed the idea of a questionnaire that would help pupils of different ages to start to understand and name their feelings, then to recognise and articulate how their emotional and practical needs could be best met.

Our original idea was that this, in turn, would inform the school how to best support these pupils in making a positive transition up on to the next step on the schooling ladder. We spoke about creating podcasts, which had suddenly taken off as – in an absence of pre-pandemic white noise – everyone had seemingly turned to the radio and its attendant voices for comfort, Blitz era-style. We thought that we could, for example, ask representatives from university admissions teams to record messages of advice for students trying to choose subject options without face-to-face help from teachers. This new landscape made us bolder, and Elizabeth did indeed end up interviewing Cambridge's Dr Sam Lucy for this purpose. In my case, locked down with three of my daughters aged 10, 13 and 15, I was witnessing first-hand the pressures on family life inflicted by what, in retrospect, turned out to have been a beyond-terrible-for-our-teenagers combination of home-schooling, increased internet access and decreased social contact with their peers. As a consequence of this personal experience, my strand of the podcast project metamorphosed quite organically into something else.

A proposal by my LEH colleague Veronica Davies to create an online mental health awareness week – and to invite experts in their field to give seminars to parents on a range of topics that might support them in having difficult discussions with the teens with whom they were now, unexpectedly, living up close and personal – quickly took shape as a fortnightly Wellbeing Wednesday online lecture series. We arranged talks on sleep hygiene, teenage nutrition, supporting girls through puberty and online porn, to name but a few, and sent invitations to local state and independent schools to join us. The format was that Veronica and I would interview the speaker after their presentation, asking them questions posed by the parents in virtual attendance, and these talks were recorded and kept on the LEH website for future generations of parents to access when the need arose. Once we were back in school, these talks became half-termly and recently have addressed some of the more painful and pressing issues and consequences of lockdown life, namely eating disorders, substance abuse and self-harm.

The podcast idea was so successful, and so gratefully received, that when our Class of 2021 responded to the Everyone's Invited movement with their own suggestions for change, and we began to work more closely with Hampton School next door, our Year 13 pupils recorded a podcast about their efforts and – coordinated brilliantly by another LEH colleague, Juliet FitzGerald, who joined the programme the following year – created a set of age-appropriate PSHE lessons to be taught across the school by LEH peer mentors, trained by Richmond Borough Mind for this purpose. This took place across a two-day series of workshops, during which I invited Ian in to run Insights Discovery with our leavers, providing them with a futureproof passport and an awareness of their needs and how they might best be met both at university and in the workplace – thus reflecting the shared intention of our community project the previous year. I designed the workshops in collaboration with Suzanne, my original mentor on the programme, and I delivered my *Normal People* session alongside Ian's. Everything was coming full circle, ideas were taking shape, and the dynamic change in their shape was made all the more positive and profound because they were being driven by the pupils' needs post-pandemic.

PSHE at LEH is now called Life Advice, which feels like a fair reflection of what I have been trying to achieve over these strange and at times difficult three years. The lessons I have been fortunate to learn through taking part in the programme have been multi-layered. I now represent LEH on the Coalition for Youth Mental Health in Schools, a group of state and independent schools that have come together with the think tank Public First to collect data on the impact of Covid on the mental health of young people, and to discuss how pastoral care and PSHE content in schools can be used to mitigate its quite devastating effects, thus meeting the ever-increasing need for early intervention. One of their proposals is for an ITT route into PSHE teaching. We have already met with the Department for Education and the second stage of our work will involve showcasing good practice in schools – I have signed LEH up for a focus on PSHE and wellbeing across the whole school. Our Wellbeing Wednesday idea showed us that we need to support ourselves as teachers and parents if we are to support our pupils and daughters in turn. As proof of her integrative coaching remit, Suzanne also used the Insights Discovery programme with my four daughters and it has been more effective than any family therapy an overstretched Child and Adolescent Mental Health Services could provide!

Reflecting on this time now, I am struck by the fertile ground that can be so easily exposed and cultivated when we give potential women leaders space and permission to share their voices; when we encourage them to realise that they already possess the skillset and strengths they need to move forward and to make their ideas a reality; when we create a platform for these voices and ideas to be seen and heard. By doing this, we encourage others to follow this female lead, to internalise these role models and, ultimately, to see that we are all, in our own unique way, leaders. These past three lockdown years have, if nothing else, revealed the extent to which we can adapt and be resilient in the face of untold and unchosen change. Imagine what might happen if we started this earlier, and told our pupils and daughters that it really is OK to take up the space they need and that shapeshifting – as women so often have to do, to accommodate the various roles they inhabit – is a positive thing, as it gives them a depth, lends them a wisdom, affords them a wider perspective.

Ian's GMN shares this vision of lifting each other up and I think this is terrifically exciting – and so very needed. I could never have, would never have, imagined how the impact of being mentored by Suzanne, its ripple effect of consequences, would have looked at the start of the process. By encouraging me to focus on my values and to ensure that my work was in alignment with those, she allowed me to shift the lens away from myself and any attendant self-doubt – about my age, my lack of a linear career trajectory, my capacity to operate at this level – thus removing the impostor syndrome with which we constantly battle. Juliet, who attended the ICGS Global Forum on Girls' Education in Boston, may well have flown out feeling self-conscious but she returned glowing with an inner confidence, having been inspired and empowered by shared stories of the compelling ideas and work being done in this female space, across a community of girls' schools. She had been literally in the room where it happens. (And, incidentally, if Hamilton had been a woman, she would most definitely have not thrown away her shot.)

Life after school

How do we prepare girls for life after high school?

JERICAH JACKSON AND JULIET FITZGERALD

Our projects were concerned with developing enrichment for students beyond the classroom, with a particular focus on stretch and challenge and looking at ways in which a student's learning can be given depth, which will add to their learning experience in school.

Jericah: I had the privilege to design and launch Aldine Young Women's Leadership Academy in Houston, Texas, US. An advisory committee had collected data from the school district and the community. One of the things we found was that a lot of families needed choices and opportunities. We did not see enough women represented in STEM careers, especially minority women not taking advanced courses such as hard sciences, math and technology. So, Aldine Independent School District partnered with Young Women's Preparatory Network (YWPN), a non-profit organisation, to address the issues that we found.

With this partnership we had an opportunity to launch the school. At Aldine we follow the guiding principles PEARLS, which stands for perseverance, excellence, advocacy, resilience, leadership and sisterhood. We use this when we are out recruiting, when we are having celebrations, or even when we need to remind our school of what we are all about.

We consider how pearls are made: it starts with a grain of sand or even a food particle that gets into the shell of an oyster. The parasite becomes

an irritant, and the irritant becomes uncomfortable. But what I find fascinating about this hard-shell organism is that even though the foreign object is so uncomfortable, it doesn't expel it. Instead, it coats it with a substance called nacre; the nacre forms layer upon layer, which eventually becomes a pearl.

The irritant I just described equates to the college preparatory courses that we provide at Aldine. Those courses are difficult: they're tough, they're challenging. Even though it's uncomfortable, we make sure we level the playing field for all our girls by directing all of them into college preparatory courses. The nacre I just described is equivalent to our support system. The more nacre that you have that is coating this pearl, the more durable and more lustrous the pearl becomes.

Aldine Independent School District ensures that all our girls are given equitable access to high-quality instructional materials. With the partnership of YWPN, we take it up a few notches. We increase the level of rigour and we support them academically. All our girls take an advisory course called AVID: Advancement Via Individual Determination.

From Monday to Thursday, during first period, they come to learn to read and write effectively and to learn how to ask questions, how to take notes, how to collaborate. As well as support for their social and emotional learning needs, every Friday morning we have Sister Circle. Those Sister Circles allow us to address what we found in our data: 44% of our girls favoured or responded positively to growth mindset and 41% of them responded to "have a lot of challenges". So we use that data to address how we can increase growth mindset; how we can push back on that negative mindset. How can we ensure that they have more positive feelings, not just at school but throughout?

A lot of the girls who come from economically disadvantaged backgrounds, who come from failing schools, face trauma. This is our way of addressing and supporting them. At Aldine, leadership matters. At YWPN, one of our pillars is "responsible leadership". At Aldine, leadership is not a reward; it's a right, it's a responsibility, it's an action. So we involve our girls in leadership opportunities by getting them to be engaged in clubs and organisations. We make sure that our staff are involved in committees. We align professional development and learning

to their individual needs, focusing on creating a coherent and common pedagogical vision.

What I have learned from the PEARLS principles, as well as what we are providing for our girls, is that we want to make sure we provide a robust approach as well as producing highly confident and adaptable learners and leaders. This is what I want to share about our school and how we focus on the aims of instructional core, culture, talent and general operations. We go through an iterative process of growing every school year. Next year we will be adding a sixth and eighth grade, and every year we will add a year until we become a sixth- to 12th-grade campus. We have the support of our families, who are involved by active decision-making. We also consider our community outreach, where girls get involved in community projects such as Girls Inc and Girl Scouts.

Juliet: One of my roles is HALE coordinator. HALE stands for humanities, arts, languages and English. What I found in our school, Lady Eleanor Holles (LEH) in London, UK, is that we have addressed successfully the issue all girls' schools have had: participation in STEM. Our school has been so successful at that, it's almost been to the detriment of humanities and arts. I don't want to take away from STEM, but I want to give equal value to humanities subjects. The students at LEH do an enormous amount of extracurricular activities. It's an independent school and the facilities are incredible. They can do art, drama, music; they do Duke of Edinburgh; they do Combined Cadet Force. We've also, for a long time, looked at building resilience and mental health. I wanted to look at how we could develop academically and the skills the students needed beyond school.

The first thing I did was to complete a survey with students across Years 7-13. Only 60% of them felt they were prepared extremely well or somewhat for life after school. Additionally, 14% felt they were prepared extremely or somewhat badly. What have we done as a school to try to address that?

One of the projects I've had this year is working with my director of teaching and learning and head of middle school to set up an enrichment week for key stage 3 (Years 7-9). We're going to take them off timetable for the week; we've given them themes, so Year 7 has environment, Year

8 is movement and Year 9 is enterprise. Each year group is going to be doing a series of sessions and trips addressing the themes within this.

For example, Year 7 are going on a trip to the London Wetland Centre and that will be coordinated by geography, biology and art organising together to build a holistic approach. Year 8 are going to a number of sessions, one of which takes the themes of human movement and migration. This involves history, geography, literature and religious studies departments – again, a cross-curricular approach. In Year 9, the enterprise project links design and technology and psychology. We also have our marketing department involved.

We have academic enrichment programmes for our Year 11 students who are preparing for public exams, looking at ways we can offer them experiences and broaden their skills beyond the curriculum.

Similarities between the schools

- Girls' schools.
- High standards.
- Ethos.
- PSHE/social and emotional learning (SEL) – importance of pastoral care.
- Professional development and staff support.
- Push for metacognition and growth mindset.

Differences

Jericah: We have just finished Aldine's inaugural year, which was very successful. When we look at recruitment, not every person is for all-girls schools, even though we have a focus on providing more access to STEM.

Juliet and I also talked about admission criteria. We talked about how we have high standards. When we recruit at Aldine, we undertake a holistic review of their application. We are targeting girls who are coming from failing schools, from economically disadvantaged backgrounds. Sometimes life happens. We don't want to judge a student based on number, based on that paper alone.

We look for trends, we look for capacity, we look for potential, because we know that if we put them in the right environment, if we remove those distractors and if they have an environment in which they can thrive, it's so rewarding and refreshing. We can only imagine what the end result could be.

We are a P3, a public private partnership. YWPN is a non-profit organisation.

Juliet: LEH was founded in 1710. Single-sex schools are very common in the UK, both in the independent and state sector. We don't have that challenge of having to justify single-sex education.

We also look for potential, but we are an independent, academic, oversubscribed school; we can pick and choose our students much more.

Where we were surprised by our differences

Juliet (observations of US):

- Curriculum selection for secondary students, and the blending of subjects in the US.
- Federal system leads to strong state input rather than a national picture.
- In England, as an independent school, we don't have to follow the national curriculum but we do align to it.

Jericah (observations of UK):

- Curriculum selections for secondary students.
- The history learned in years of implementation.
- Single-sex education remains a controversial topic in the US but a norm for UK school systems.

What we learned from collaborating with each other

Jericah: I want to make sure that our school is comprehensive in its approach. We don't want to lose sight of what complements STEM – HALE. We also want to focus on developing a robust, continuous improvement approach.

Juliet: Working with Jericah has been a really positive experience and I have had two main takeaways.

I can get into an LEH bubble in our school. It's a very privileged environment and this collaboration just reminded me to step out and consider how we can attract the attention of our students, whatever the setting.

This idea of blending subjects: when I first trained as a history teacher, there wouldn't have been talk of combining geography, history and RS. But, talking to Jericah, we can see the strength of combining subjects given that much more holistic approach. That made me step out of my fixed mindset.

Experience of being mentored

Jericah: Lois Mufuka Martin was my mentor and having those conversations really helped me to focus on having courage and trust in myself. When I have those difficult conversations, I hold people accountable. It can be scary when people are not executing the vision that you are very passionate about, but I focus on trusting myself and I celebrate our accomplishments. The book Lois shared with me – *What Got You Here Won't Get You There* by Marshall Goldsmith (2008) – definitely helped me because during the inaugural year, one naturally defaults to one's past experiences. As a principal, I default to assistant principal. I have to realise, no, I'm in this new role, so I have to focus on that role and having a different mindset.

Juliet: I found the experience of being mentored really interesting. For me, it wasn't what I was initially expecting. I think I was hoping for a broader, big-picture focus and actually what my mentor, Jo Beckett, and I would do was to look at specific challenges or problems that I was facing on a smaller scale. We would talk it through and go quite into the minutiae and set a timeframe. What I found from that looking back was that I was able to deal with the issues I had with those projects and I have since applied that to the way that I go about things. So I have achieved that big picture that I was hoping for. It's definitely helped with my personal and professional growth.

My big takeaway from Jo was to strip out the emotional language and have a mantra to remind myself to do so.

Unresolved questions/future plans

Jericah: I want to ensure that no one is left in the margin. It's not just the students; it might also be the families I need to focus on. Some of our families may not know English. We may have students who come in who have social needs. Those are some of the things I want to pay attention to.

Juliet: I feel I have a long way to go but a much clearer picture of where I want to go. I'm pleased with the academic enrichment programme I've developed. I feel I understand the purpose of it better. The big thing is making it explicit to the pupils why they are doing this and what they can get from it.

A playbook for teaching the skills and mindsets needed in a diverse and changing workplace

MARGARET POWERS AND DIANA KELLY

What the Insights Discovery survey taught us about ourselves

Diana: I am a Directing Motivator. My strengths include a strong work ethic but also the ability to see the big picture, look for possibilities and seize the positive in situations. I'm enthusiastic and constantly striving towards self-improvement. I did think that the results and my report echoed the way I feel about myself quite strongly.

Margaret: I am a Coordinating Supporter – opposite to Diana. Some of those key strengths from the survey, which again resonated with me, were that I'm patient, relaxed, open-minded and have strong organisational skills. I am someone who is compassionate and someone who likes to look before they leap – to plan ahead and know what I'm getting into. I am someone who is skilled at defusing tense situations and I have strong personal values. I prefer a sense of structure and I learn from experience, so that I don't end up in the same challenging situation twice in a row.

What we both noticed was that apart from pulling out our strengths, the profiles highlighted where we work well as a team – we pulled on this during our time on the project. For me, it was about persistence and tenacity, some ingenuity and the imagination to come up with

clear solutions. I also set high personal standards for the work that we produced.

Diana: We were opposites, but we drew upon each other's strengths and complemented each other rather than clashed. I relied heavily on Maggie's project management skills and abilities. My strengths aren't necessarily technical or organisational. I really appreciated Maggie's patience and ability to focus on the outcome constantly, so that I had the structure I really needed to be able to work at my best. I found that I used my strengths in building relationships and talking about our contexts and how similar they are. I did find that interesting and we reflected on that after each of our meetings. Where we came together is that we both have a passion for preparing students for life after school and their ability to be able to cope and thrive in the workforce. To what extent are we preparing our students for that? My big-picture, conceptual thinking was focused on that – where are our students going? Maggie's creativity helped us to narrow it down to something that we could tangibly work with.

Margaret: Diana is very flexible and good at building relationships. It felt like we were tackling a problem together, which made it possible to persist with our project even when we hit a number of challenges – in the US over a single school year and in Australia over two years. Making something that was meaningful was important to both of us. We have this shared interest in looking at the needs of learners today and ensuring that they have this awareness of the larger world around us. We looked at the systems that are at play and the structures that may or may not be supporting our students in school to go out and succeed in the world at large. We realised we couldn't change the careers they would be going into or how they were prepared for those careers, but maybe we could start with the actual skills they would need to be successful. We also wanted to look at the idea of exposure to more skills and to developing mindsets, with the hope that students would get comfortable learning new skills in a way that they would continue to need to do when they leave school. We wanted to explore the idea of upskilling, continually taking on new skills and knowing what to do with those skills in new contexts.

We realised we needed to create a skills inventory or assessment and give that to students in both schools, but to do that robustly was too challenging in this ongoing pandemic, with large numbers of students and staff out at times. There were also a number of other initiatives that schools were trying to get back on track after two years of, at least in part, virtual learning. However, we realised that we could create a playbook that we could share not only with our schools but also with any school – indeed, with the entire International Coalition of Girls' Schools community.

Our goal was to create some workable strategies and solutions that people could implement in their own contexts to try to begin the teaching of these 21st century skills wherever they are starting from. Whether you are just one teacher with one class or trying to implement a school-wide programme, there should be some ideas in our playbook that you can work with in your classes immediately. We focused on how we teach and assess these soft skills in different contexts and what that can look like, moving away from the traditional method of focusing on content towards the skills that students will need in order to cope with the demands of the ever-changing workforce.

A strength of our partnership was that we had a lot of similarities in terms of the challenges our schools are experiencing through the pandemic, both being rooted in tradition and with faculties managing robust curricula. However, we also have things that are unique to our schools, which allowed us to think about different contexts and how this playbook helps to support teachers and school leaders in different settings and around the world. We used these differences to create responses to a variety of scenarios and create resources for different pathways you could follow in the playbook.

Creating Skilled Global Citizens: a playbook for teaching the skills and mindsets needed in a diverse and changing workplace

Diana: There is an introduction on how you get started with introducing an initiative like this in your own school. We have a section called "Go big or start small" – do you want to try this in one section of the course, start with one course or one grade level, or with the entire school? We walk you through this thought process and help you figure out the skills

and mindsets most important to your school, with some examples of what that might look like. We give you ideas and resources to help you work out what skills you would like to assess. We point you to research that identifies what critical skills are used in the workplace today and what related mindsets need practising, with examples. We guide you through how to choose someone who will nurture and guide the school through the project and help you with your communication plan, with sample letters at the end.

The strategies for teaching the course are designed to be implemented in any context, so although the examples are from Australia – the Victorian curriculum – there are ideas on how they can be adapted for any curriculum, with additional resources. There are sample rubrics to show how to put these skills into an assessment task, in different formats. It is designed to be a practitioner playbook, so it is something you can start to use immediately. It's not too deep in the theory as we wanted it to be very practical, so it has step-by-step ideas and instructions. If you are excited about this work and want to implement it, we have outlined the steps we went through to do this. We talked to others about how this might work in different contexts and we would really encourage others to build a network, find other schools interested in implementing this initiative and work together, becoming accountable to each other as you work through the playbook and figure out what mindsets and skills are most important for your students. We have shown in our collaboration that a partnership with another school, anywhere in the world, is a powerful piece of the success and outcome of the programme.

As we worked together on this project, we realised that, just like our students, skills and mindsets are important for us too – both personally and for our colleagues in schools. So, we should then consider what could be offered to enable teachers to learn skills and mindsets and to upskill – applying those same ideas that are seen in the corporate world. When we created the playbook, we were drawing on our own personal experiences that were really quite different, but in putting it together we were able to create something robust.

Reflecting on my career, I could see the importance of these skills but also the challenges for schools in teaching them in a meaningful way.

We should not lose sight of the integral importance of these skills for our students, so it is worth fighting the good fight to deliver this teaching, as much as our contexts allow us to. Whether it is something you simply talk to students about, whether you cannot dive in as deeply as we did in this initiative – every touchpoint has its impact. We should model these skills and mindsets for students, as we are still learning as adults and these approaches are still valuable in our everyday lives, be that at work, home or the wider world.

To read an excerpt from the playbook, including the introduction, "Getting started" chapter and "Resources" chapter, go to: bit.ly/PowersKelly

Author biographies

Isabelle Alexander

Isabelle Alexander is the head of neurodiversity and hidden differences at Wimbledon High School in London, UK. Following a successful career in marketing and having discovered that one of her daughters was dyslexic, Isabelle changed paths and trained to become a specialist teacher. A few years later, she undertook further study to become a specialist teacher assessor. Since joining Wimbledon High School in 2017, she has changed the way learning differences are approached in the school and has worked towards demystifying and increasing acceptance of neurodiversity and hidden differences for students, staff and parents. Isabelle also has a private practice and, along with assessing individuals for learning differences, she regularly provides consultancy and assessment services to other schools. She is passionate about ensuring all students achieve their true potential.

Kathryn Anderson

Kathryn Anderson is the director of student life at Holy Name of Mary College School in Ontario, Canada. With a master's in education, focusing on digital technologies, and over 10 years' experience in girls' education, she believes in creating an environment where young women can take healthy risks and feel supported, in order to thrive in the modern world. Kathryn's most recent area of research has been student wellness and its interconnectedness with overall student success and preparedness for the world. The project completed as part of the Global Mentoring Network, "Balancing act: understanding and planning for student wellness",

was the beginning of a multi-year project aimed at personalising non-academic student programming to students' individual learning needs.

Kate Banks

Kate Banks is a committed educator who has worked in the public and independent sectors in Australia. She has a keen interest in developing innovative and dynamic learning experiences, and engaging learners through the transdisciplinary inquiry approach to education. Kate is currently the Years 3-6 coordinator and a Year 5 teacher at Korowa Anglican Girls' School in Melbourne, Australia. During her time at Korowa, she has worked to ensure her students gain the knowledge and skills necessary to succeed as 21st century learners, through programmes such as STEM and experiential learning. Kate's most recent research regarding mastery learning begins to explore alternatives to traditional assessment practices.

Punam Bent

Reverend Punam Bent is an experienced school chaplain (Master of Ministry, Charles Sturt University, Australia; Master of Divinity, Theology, United Theological Seminary, Ohio, US) with a history of working in the independent primary/secondary education sector, specialising in girls' education (K-12). Punam has taught in the area of religion and ethics in her role as chaplain (at MLC School and Pymble Ladies' College in Sydney, Australia) since 2003, specialising in areas of wellbeing, spirituality and social justice with a focus on regional partnerships, environmental action, raising First Nations awareness and engagement, and promoting religious and cultural diversity. She is an ordained minister of religion practising within the Uniting Church in Australia and the United Methodist Church in the US since 1992.

Kate Brown

Kate Brown has been teaching across kindergarten to Year 8 for more than 15 years, since changing careers from family law to education. In her career as an educator, Kate has been a class teacher, deputy head of learning and head of student wellbeing K-6, before becoming head of junior school at Pymble Ladies' College in Sydney, Australia, in 2020. Kate's approach to teaching and learning centres around the philosophy

that each child deserves to learn in an environment that celebrates their unique strengths and encourages them to have a go, make mistakes and embrace their learning as a journey. She believes that a learning community founded in kindness will empower each child to flourish as a learner and leader. Through a focus on kindness, Kate hopes to inspire students to be kind, not only to themselves, and to share their ideas with others and positively impact their world.

Clare Duncan

Clare Duncan has been in education for the past 22 years. She is currently deputy head (academic) at Wimbledon High School in London, UK. After graduating with a mathematics degree from Sheffield University, Clare qualified as a management accountant, working with British Telecom International before moving to American Express. Returning to her love of mathematics, Clare trained to be a mathematics teacher. As a reflective practitioner, she is forever looking for new initiatives to inspire students and believes that the heart of teaching is enthusiasm; passion is infectious. She is a firm believer that students should be known as individuals, and aims to build a curriculum and a mode of delivery that equips them with the skills and knowledge they need to succeed at school and beyond.

Juliet FitzGerald

Juliet FitzGerald grew up and attended school in London, UK. After studying for her BA in history at Newcastle University, she completed an MA at Central School of Speech and Drama. She worked in a variety of industries, including performing in an improvised comedy show at the Edinburgh Festival, before a year teaching in Tanzania made her realise her love of education. She has taught history and politics in state and independent schools and is currently head of initial teacher training, HALE (humanities, art, languages and English) coordinator, enrichment coordinator and a digital leader at Lady Eleanor Holles in London. Juliet is passionate about education and how we can constantly reflect on our teaching and learning practice to get the best from our pupils. She lives in London with her partner and three children.

Michelle Fitzpatrick

A contemporary leader in shaping girls' education internationally over 24 years, Michelle Fitzpatrick has a deep understanding of innovative educational programmes and a desire to develop future-ready girls who exercise agency, with high levels of digital and data literacy. As a transformer, creative thinker and passionate leader, Michelle has enabled hundreds if not thousands of girls to change their lives, or the lives of others, by designing and leading student-centred initiatives. By developing portable skills and confidence, engaging in dynamic community partnerships, reviewing social responsibility, and promoting sustainability and its effects on the world, students can now collaborate for a common purpose.

Cathryn Furey

Cathryn Furey is deputy principal, director of learning at Ruyton Girls' School, an independent non-denominational girls' school with approximately 950 students from kindergarten to Year 12 located in the eastern suburbs of Melbourne, Australia. Cathryn is privileged to play an integral role in a future-focused, collaborative executive team, having direct and significant impact on the transformation of learning and wellbeing from early learning to Year 12. Cathryn has over 30 years' experience in Melbourne independent girls' schools and is committed to providing learning experiences that empower young women to flourish and strive for personal excellence.

Alexandra Greenfield

A Teach First ambassador, Alexandra Greenfield began her teaching career in 2015. Over the past seven years, she has taught English, film studies and media studies in the state and independent sectors. Since 2019, she has held the role of head of English at St Albans High School for Girls in Hertfordshire, UK. In 2018, Alexandra completed a master's degree in leadership at the Institute of Education in London; in 2022, she was awarded chartered teacher status from the Chartered College of Teaching. An advocate of evidence-informed teaching practice, Alexandra's interests lie in understanding what makes great teaching. As such, she remains significantly involved in her school's CPD programme, delivering workshops to staff and contributing to the development of

the in-house Early Career Framework programme for new teachers. Alongside her counterpart in the history department, Alexandra co-authored an article for *Impact* magazine on diversifying the English and history curriculums, and has led multi-school TeachMeets focused on better aligning the English and history curriculums. In the classroom, Alexandra delights in bringing literature alive for her students; she will never stop being excited, and seeking to excite students, about the power of the written word.

Rachel Hart

Rachel Hart is head of PSHE at Lady Eleanor Holles in London, UK. She has more than 20 years of experience teaching in girls' schools and has four daughters of her own. Rachel has trained in child, adolescent and family mental health and wellbeing at the Tavistock clinic in London and brings a therapeutic lens to her work in the classroom and beyond. She is passionate about providing opportunities for girls and young women to find their voice and to discover their individual and collective strengths through mentoring and collaboration.

Kate Hawtin

Kate Hawtin is head of sixth form at St Catherine's School in Surrey, UK, an independent boarding and day school for girls aged 4-18. She is responsible for overseeing the pastoral wellbeing of around 170 girls aged 16-18, as well as advising on and submitting their university applications. She teaches Spanish to various year groups, having been head of Spanish before moving to her current senior management role. Kate has worked at St Catherine's since she qualified as a teacher; she studied her PGCE at the University of Southampton and her BA in modern European languages at the University of Durham.

Jericah Jackson

Dr Jericah Jackson holds a doctorate in educational leadership from Texas A&M University-Commerce, a master's degree in educational administration from Sam Houston State University, and a bachelor of science degree from Baylor University, all in Texas, US. She entered the education field, where she felt energised to pursue her efforts in teaching and service. As her passion increased for social justice in the

public school sector, she sought to provide equity in education for all students through instruction, service and research. After beginning her career leading mathematics and science classrooms at the middle school level, Jericah served as the assistant principal at Aldine Middle School in Houston and assistant principal of curriculum and instruction at the Shotwell Academy, an International Baccalaureate Middle Years Programme school also in Houston.

Jericah's dissertation received the 2021 Edgar L Morphet Dissertation of the Year Award from the International Council of Professors of Educational Leadership and the 2020 Outstanding Dissertation of the Year Award from the Texas Council of Professors of Educational Administration. She has piloted programmes in mathematics education at the campus level that expanded throughout the district towards providing equity in education for underserved students, specifically at Title I campuses. Jericah has served on the following committees: Houston Area Alliance of Black School Educators, Young Women's Preparatory Network Scholars Grading Committee, Aldine Superintendent-Principal Advisory, and Aldine ISD Design Committee to refine and pilot a new evaluation system to measure and incentivise teacher performance. Currently, Jericah leads an A-rated school (according to the Texas Education Agency 2022 Accountability Report) in Aldine Independent School District, as founding principal of the Aldine Young Women's Leadership Academy, which focuses on college preparatory academics for girls in Grades 6-12, with an emphasis on STEM, college readiness, leadership development, and health and wellness.

Diana Kelly

Diana Kelly is a teacher-librarian who has worked in the public and private school systems in Melbourne, Australia. She has a special interest in supporting students through all stages of the research process, meeting them at their point of need, and developing the most appropriate research approaches for their individual skills, confidence and experience. During her career, Diana has focused her attention on strengthening her skills in teaching critical thinking and research skills, and continually developing and refining her approach to formative and summative assessment tasks to measure student outcomes in these

skills. As a teacher-librarian, Diana finds collaborating with teachers to develop rigorous and engaging research tasks particularly rewarding, as the shared knowledge can have a powerful impact on student learning. She believes focused attention on teaching critical thinking and research provides young people with skills that they will not only take with them to all subjects, but into their lives beyond school.

Susanna Linsley

Dr Susanna Linsley is the director of experiential learning and a teacher in the humanities programme at the Webb Schools in California, US. She received her BA in history from Mount Holyoke College in Massachusetts and her MA and PhD in early American history from the University of Michigan. Suzi's pedagogy is built around moving students out of their comfort zones by cultivating their curiosity and desire to connect to the world around them. She teaches classes in environmental humanities and sustainability, gender studies, Indigenous studies, politics and culture of the US/Mexico border, the American Revolution and the Atlantic World, and a humanities research seminar. Suzi lives at Webb, a boarding school faculty, with her two amazing children, where they love to spend their time reading, swimming, hiking, camping, exploring and travelling.

TC Nkosi-Mnanzana

TC Nkosi-Mnanzana is a mathematics teacher with experience in teaching senior and FET (further education and training) phase mathematics. Her teaching journey began at St Andrew's School for Girls in Johannesburg, South Africa, where she taught mathematics, worked as a boarding house matron and coached netball in the U14 division. She later joined the Pioneer Academies group, where she taught mathematics in the IGCSE curriculum. Besides mathematics, outreach has played a pivotal role in TC's life. In every school she has worked at, she has always been an active member of the community engagement initiatives, putting to use her love of mathematics at St Andrew's with their uBambiswano programme and later founding POP (Pioneer Outreach Programme) at Pioneer Academies. After 10 years of teaching, TC transitioned out of the traditional classroom and started working in an educational outreach programme. In her role as programme director at Thandulwazi Maths and Science Academy, she was responsible for

the 1000-student Saturday school programme, the teacher development programme in two provinces in South Africa, the intern teacher programme and the scholarship programme. Working at Thandulwazi affirmed TC's view that education truly can shape and transform one's life. In 2020, she joined Nova Pioneer as global culture manager, where she worked to catalyse culture-building in 13 schools across South Africa and Kenya. Currently, TC is deputy head of St Stithian's Girls' College in Johannesburg, looking after student affairs and student wellbeing.

Ellie Peaks

Ellie Peaks has worked in education for 13 years in five charter and independent schools in the US. She began her career teaching middle school reading, writing and humanities for 10 years, before moving to her current role in the co-curriculum programme at the Madeira School in McLean, Virginia, US. She is passionate about working with other educators on mission-driven curriculum and strategising the best ways in which we might connect our "why" with our "how". Ellie likes to spend her free time baking, playing with her two dogs, and hanging out with her husband and newborn daughter.

Margaret Powers

Margaret Powers has over a decade of experience, on three continents, in designing and facilitating learning experiences, engaging in programme design and creating instructional resources for educators. She is a constructivist educator with a deep respect for all learners of any age. She has worked with students and teachers from pre-K through 12th grade, engaging them in making, design thinking, computer science and project-based learning. Margaret is the founder of Creative Thinking Partners, where she partners with schools to provide leadership and instructional coaching, design professional learning experiences and use design sprints to engage community members in transforming their school culture. She has developed and led faculty induction programmes, designed makerspaces and created hands-on STEAM curricula. Margaret has supported fellow educators and school leaders in professional learning communities and led strategic plan implementation workshops. She has taught online courses for educators around the world and facilitated numerous workshops, in the US and internationally, on

innovative practices in education. Margaret was named a PBS Digital Innovator in 2014, an Exceptional Emerging Leader in 2015 and became a Google Certified Innovator in 2016. She received her BA from Bryn Mawr College in Pennsylvania and her master's in international training and education from American University in Washington DC. Margaret is passionate about creating innovative approaches to learning that inspire students and educators to rediscover the joy of learning. She believes the key to making learning engaging and meaningful is using human-centred design principles and a competency-based approach to skills and feedback.

Tara Quenault

Tara Quenault is the head of science and a teacher of senior chemistry and junior general sciences at Melbourne Girls Grammar in Australia. She received her BA in German language and literature and her BSc (Hons) in biochemistry and molecular biology from Monash University in Melbourne. Tara's scientific research at the Commonwealth Scientific and Industrial Research Organisation and Monash University centred around evolutionary genetics and transcriptomics, and it was in the postgraduate teaching spaces that she realised her passion for the classroom and subsequent desire to explore that in her career. Tara completed her secondary teaching studies at the University of Melbourne and her pedagogical focus is constructing interdisciplinary understanding alongside her students, aiming to connect knowledge within and across disciplines to wider sociocultural contexts. Tara is particularly excited by the ways in which the power of narrative course design can be used to contextualise scientific ways of thinking and doing for her students, and is fascinated by the intersections of science with English, humanities and the arts. Tara enjoys reading, hiking, travelling, concerts, plays and wholehearted conversation over dinners with friends and family.

Erin Skelton

Erin Skelton has been an educator for the past 15 years and has undertaken many school leadership roles, both academic and pastoral, as head of department, head of key stage 4, strategic subject leader, head of sixth form and assistant head. Her career has spanned the

state and independent sectors, co-educational and single-sex, in both faith and secular schools. Her background is in teaching and learning, pastoral and coaching strategy, careers guidance, leadership strategy, equality, diversity and inclusion strategy, educational research, and school improvement. Erin is an inspirational public speaker and trainer with a passion for safeguarding, pastoral care and ensuring every learner is as successful as possible.

Joanne Wallace

Joanne Wallace is a passionate and knowledgeable educator with 20 years' experience as a teacher, mentor and leader within the maintained and independent sectors. Working closely with the senior leadership team, she has developed and implemented a pupil progress improvement strategy, a new curriculum for five- to seven-year-olds, developed the rewards ethos of her school, and is recognised as key member of the leadership team in leading change and improvement. Joanne believes that all children should love to learn. They should experience education that ignites curiosity and inspires them to learn, explore and enjoy their childhood. She strives for an education that challenges a child's thinking and perceptions, enabling them to progress and develop as citizens of the world. Failure should be encouraged and welcomed, because only by risking failure do we try things we find difficult. Joanne is currently the head of pre-prep at Abbot's Hill School in Hertfordshire, UK, where she leads nursery to Year 2. Her passions in life are travel, outdoor adventure and balancing all this with being a mum to Jessica, Harry and Benjamin, who are the reason she is so passionate about raising the next generation to have integrity and to be empathetic, loyal and caring people in the world.

Stephanie Walton

Stephanie Walton is an experienced and passionate teacher of psychology with over 10 years' experience teaching A level, IB and VCE (Australian) psychology. She currently teaches senior years psychology and is director of teaching and learning (7-12) at Melbourne Girls Grammar, Australia. She coordinates the Learning Area of Psychology course at the Melbourne Graduate School of Education at the University of Melbourne and guides aspiring pre-service teachers in their teaching of psychology. Stephanie

is passionate about providing effective and meaningful professional learning to teachers and recently founded AusTOP, a national network of Australian psychology teachers. AusTOP advocates for the inclusion of psychology in the national curriculum and provides valuable professional learning opportunities throughout Australia.

Karen Whelan

Karen Whelan began her teaching career in 1995 as a geography and psychology teacher. She has spent most of her career within the Australian independent school sector, but has also taught in Catholic schools and spent time teaching in the government schools overseas. She has held middle and senior leadership roles in the areas of wellbeing, curriculum, staff, teaching and learning, operations, professional development and research. As a leader, Karen fosters a collective culture with collaboration at the centre, to ensure that her teams leave education in a better place than they found it. She is a passionate advocate for the explicit teaching and embedding of metacognitive skills and their direct relationship to the growth of creative, critical and independent learners. Karen has a master's in education from the University of Melbourne, has co-authored VCE psychology textbooks and related teacher support materials, and is a regular presenter at the CDES psychology teachers' conference.

Acknowledgements

When we first sat down as a board in 2016 to discuss the idea of a pro bono mentoring programme to improve the pipeline of women's leadership in girls' schools, none of us could have imagined the impact the next six years would have on us as a team, or on the group of leaders we have had the privilege to work with. The Girls' Schools Association has been a continuous source of support in that time, with Donna Stevens and Imogen Vanderpump now at the helm.

Including the present cohort, more than 200 colleagues have participated in the programme. As well as trusting us with her Australasian colleagues who joined the programme, Loren Bridge of the Alliance of Girls' Schools Australasia proposed the idea of a student mentoring network. A pilot programme of a further 45 students is about to be completed, despite the Covid-19 pandemic forcing us to challenge many of the assumptions and rules that we thought were inviolate, thus bringing about new ways of working, teaching and learning, and relating to one another.

At the now International Coalition of Girls' Schools (ICGS), Megan Murphy found time to join us on our shared journey while leading the transformation from the National Coalition of Girls' Schools. Jen Evers was a constant source of inspiration, advice and friendship as we navigated our way through the year.

Our mentors now stretch from Australia to Europe and had themselves to be flexible to the timetables and day-to-day professional and domestic pressures of their mentees. In many cases they worked with colleagues in remote parts of the world, becoming adept at managing clocks as

northern and southern hemisphere time zones changed over the course of the year. Particular thanks to Jo Beckett, Anne Chatroux, Maxine Evans, Caroline Hoare, Niki Kahn, Lois Mufuka Martin, Dana Nunnelly, Adrienne Penta, Martin Seeley, Vanessa Stair, Jeremy Tomlinson, Brooke Weimann, Suzanne White and Marjon Wind.

At the ICGS Global Forum on Girls' Education in Boston, Camilla Chandler-Mant was a wonderful support in manning our stand, engaging with delegates and ensuring we met our varied obligations as sponsor, speaker and facilitator. At the JFK Library, Michael Hancock went beyond the call of duty in sharing so generously the Bobby Kennedy materials mentioned in the prelude to this book. At the Boston Athenaeum, Victoria O'Malley gave a wonderful impromptu tour of the inspiring library, which we hope will play a part in a future event. Jane Carroll, wearing a new ICGS hat, thoughtfully found us an opportune location on the conference floor and continues to be a generous source of help and advice.

When we were faced with the need to film the Boston conference, Carrie Hughes-Grant and Kathryn Anderson from Holy Name of Mary College School had a wonderful suggestion: to enlist one of their students, an accomplished filmmaker. On the day, Cristina Racco skilfully manoeuvred three cameras single-handedly. Over the summer, Cristina edited more than 24 hours of footage into a coherent series of 15 films, to enable the transcriptions you have just read, many of which were produced by Kate Doarks.

Alex Sharratt at John Catt had helpfully seen this book as the second part of a possible trilogy, but it took a conversation between Dana Nunnelly and Hilary Wigston to come up with the title. In turn, this was interpreted brilliantly by Matt Saunders, who designed our cover, and Isla McMillan, who once again wielded her editorial pen with sensitive judgement and skill.

Other friends and family have continued to be supportive of this work. At the Royal Society of Arts in London, conversations with Andy Haldane, Anna Bozic and the ever-welcoming Babs Lemon make the House a very special place.